The Age of Reptiles

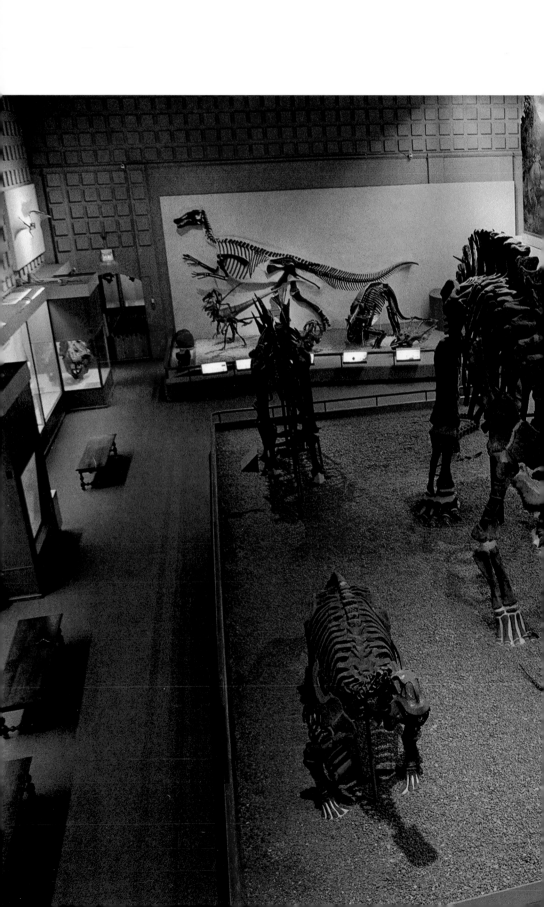

The Age of Reptiles

The Art and Science of Rudolph Zallinger's
Great Dinosaur Mural at Yale

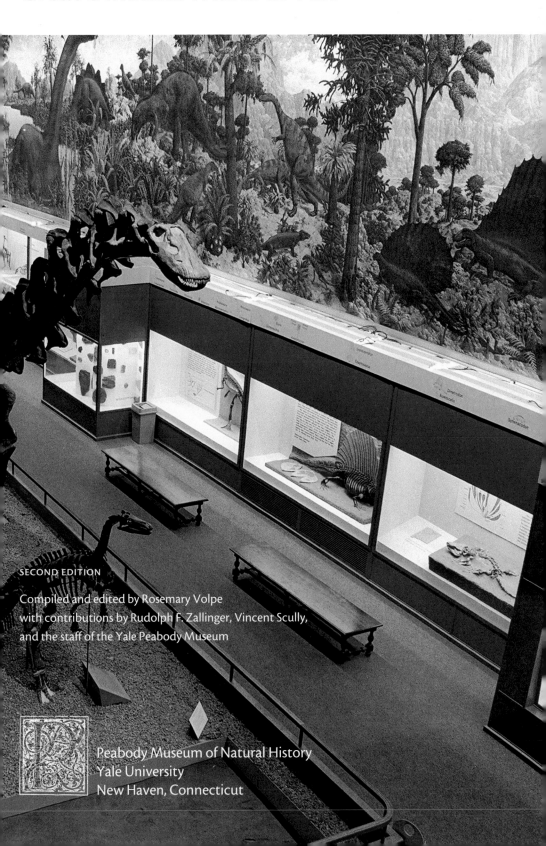

SECOND EDITION

Compiled and edited by Rosemary Volpe
with contributions by Rudolph F. Zallinger, Vincent Scully,
and the staff of the Yale Peabody Museum

Peabody Museum of Natural History
Yale University
New Haven, Connecticut

The chapter "Life and Landscape in the Mural" is a revision with new material of "The Life in the Mural" from *A Guide to the Rudolph Zallinger Mural The Age of Reptiles in the Peabody Museum of Natural History*, Yale University, 2nd edition, by J. H. Ostrom, L. J. Hickey and T. Delevoryas, © 1987 Peabody Museum of Natural History, Yale University; and of "The Life in the Mural," by L. J. Hickey and J. H. Ostrom, in *The Great Dinosaur Mural at Yale: The Age of Reptiles*, New York: Harry N. Abrams, Inc., pp. 24–48, © 1990 Peabody Museum of Natural History, Yale University.

"Creating the Mural" by Rudolph F. Zallinger is reprinted from *The Great Dinosaur Mural at Yale: The Age of Reptiles*, New York: Harry N. Abrams, Inc., pp. 18–23, © 1990 Peabody Museum of Natural History, Yale University.

"*The Age of Reptiles* as a Work of Art" by Vincent Scully is reprinted, with minor corrections, from *The Great Dinosaur Mural at Yale: The Age of Reptiles*, New York: Harry N. Abrams, Inc., pp. 24–48, © 1990 Peabody Museum of Natural History, Yale University.

Additional material adapted from:

"Special Exhibit Marks the Awarding of the Verrill Medal to Rudolph Zallinger," pp. 38–39, and "Rudolph Franz Zallinger: Portrait Artist of the Earth," pp. 40–41, by Zelda Edelson, *Discovery* (15)1, © 1981 Peabody Museum of Natural History, Yale University.

"An Interview with Rudolph F. Zallinger," pp. 33–35, by Lee Grimes, *Discovery* 11(1), © 1975 Peabody Museum of Natural History, Yale University.

TITLE PAGE: *The Age of Reptiles* mural overlooks the mounted dinosaur skeletons in the Yale Peabody Museum's Great Hall. Photograph by William K. Sacco. © 2005 Peabody Museum of Natural History, Yale University. All rights reserved.

 Yale University

The Age of Reptiles
The Art and Science of Rudolph Zallinger's Great Dinosaur Mural at Yale

Compiled and edited by Rosemary Volpe with contributions by the staff of the Peabody Museum of Natural History, Yale University, Michael J. Donoghue, Director

Library of Congress Cataloging-in-Publication Data

The art and science of Rudolph Zallinger's great dinosaur mural at Yale / compiled and edited by Rosemary Volpe ; with contributions by the staff of the Yale Peabody Museum. – 2nd ed.
 p. cm.
 Rev. ed. of: The great dinosaur mural at Yale / Vincent Scully ... [et al.]. 1990.
 Summary: "This illustrated overview of Rudolph Franz Zallinger and the fresco secco mural The Age of Reptiles he painted at Yale University's Peabody Museum of Natural History describes the prehistoric life shown in the mural, highlights from the Peabody's history and collections, and the place of the mural in the history of art; includes a foldout color poster"–Provided by publisher.
 Includes bibliographical references.
 ISBN 978-0-912532-76-9 (wire-bound tradebook with poster)
 1. Reptiles, Fossil–Pictorial works. 2. Paleontology–Devonian–Pictorial works. 3. Zallinger, Rudolph F. Age of reptiles. 4. Reptiles in art. 5. Peabody Museum of Natural History. I. Volpe, Rosemary, 1958- II. Peabody Museum of Natural History. III. Great dinosaur mural at Yale.

QE861.A78 2007
567.9022'2–dc22
 2007006875

The Age of Reptiles, a mural by Rudolph F. Zallinger. Photograph by William K. Sacco and Joseph Szaszfai. © 1990, 2001 Peabody Museum of Natural History, Yale University, New Haven, Connecticut, USA. All rights reserved.

Unless otherwise noted, photographs are from the archives and collections of the Yale Peabody Museum. © Peabody Museum of Natural History, Yale University. All rights reserved.

© 2007 Peabody Museum of Natural History, Yale University, New Haven, Connecticut, USA. All rights reserved.

No part of this book may be used or reproduced in any form or by any means without the written permission of the Peabody Museum of Natural History, Yale University, P. O. Box 208118, New Haven, Connecticut 06520-8118 U.S.A; www.peabody.yale.edu.

Printed in the United States of America.
ISBN 978-0-912532-76-9

Contents

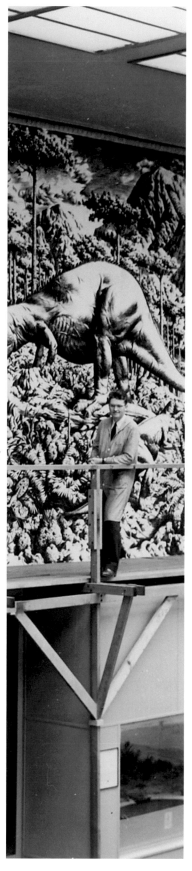

Preface

For six decades Rudolph Zallinger's *The Age of Reptiles* has had an enduring influence on the imagination of not only visitors to the Peabody Museum of Natural History in the Science Hill section of Yale University's campus in New Haven, Connecticut, but to admirers worldwide. Appropriate to its scope and stature as a unique work in the history of both art and science, Zallinger's painting has been

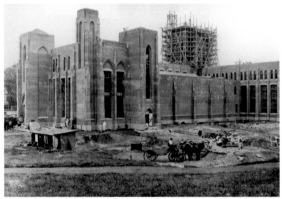

reproduced for museum audiences as far away as Japan and Australia, as well as in countless magazines, textbooks, and works for children.

It has especially figured prominently in the life of the Yale Peabody Museum. *The Age of Reptiles* mural is still being used to teach and inform the more than 35,000 schoolchildren and 115,000 other

The current Yale Peabody Museum building, seen from the rear, under construction at Sachem Street and Whitney Avenue in New Haven, around 1924. The cornerstone, laid during Commencement Week, on June 18, 1923, contains documents relating to the history of the Museum and Yale.

visitors that walk through the Museum's Great Hall each year.

This revised edition of the Peabody's guide to Zallinger's masterwork ambitiously seeks to expand this experience and to carry it beyond that great room full of dinosaurs and history to a new audience. A compilation of earlier material and new information contributed by the staff and scientists of the Yale Peabody Museum, *The Age of Reptiles: The Art and Science of Rudolph Zallinger's Great Dinosaur Mural at Yale* is intended to be more comprehensive in its scope than earlier guides. The descriptions of the life and landscapes depicted in the mural have been updated to reflect current knowledge in botany, zoology, paleontology, and geology—information unknown and undiscovered in Zallinger's time—and have been enhanced with highlights from the Museum's distinguished history and rich collections.

Also told here is the story of Rudy Zallinger and, in his own words, the making of the mural, along with Vincent Scully's classic treatise on the mural's place in the history of art. As memory evolves into history, this guide seeks to document the place of this remarkable artist and his work in the larger story of the Peabody Museum at Yale.

This new edition is also useful for students and educators as an overview of prehistoric life, and includes a glossary and list of resources for more

in-depth inquiry into the vast amount of material available on the ever-changing science of the history of life on this earth. The accompanying color foldout poster is designed to be a companion to this guide; it includes identifying illustrations of the animals and plants shown in the mural, and a geologic timeline, both intended to ease the use of this unique panorama of ancient life in the classroom. We hope that this much condensed summary of the sweeping story told in *The Age of Reptiles* will adequately explain the principal features and concepts of the mural to both those new to Zallinger's work and those familiar with the Peabody and its history, and give a sense of the remarkable achievement that is *The Age of Reptiles* mural.

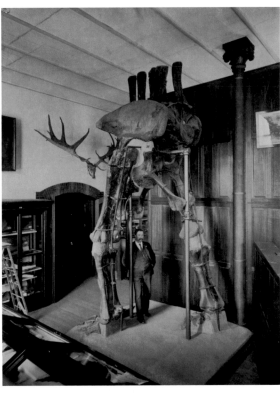

Hugh Gibb, the Peabody Museum's fossil preparator, here stands next to the mounted hind limbs of *Apatosaurus*, c. 1902, all that the height of the ceiling of the original Peabody building would allow.

The Age of Reptiles: The Art and Science of Rudolph Zallinger's Great Dinosaur Mural at Yale is the product of the efforts of many individuals, past and present, in the Peabody's curatorial divisions, archives, and its education and public program departments, who generously contributed their time and expertise, ideas and stories. The result, we hope, does justice to the history, science, and art of *The Age of Reptiles*.

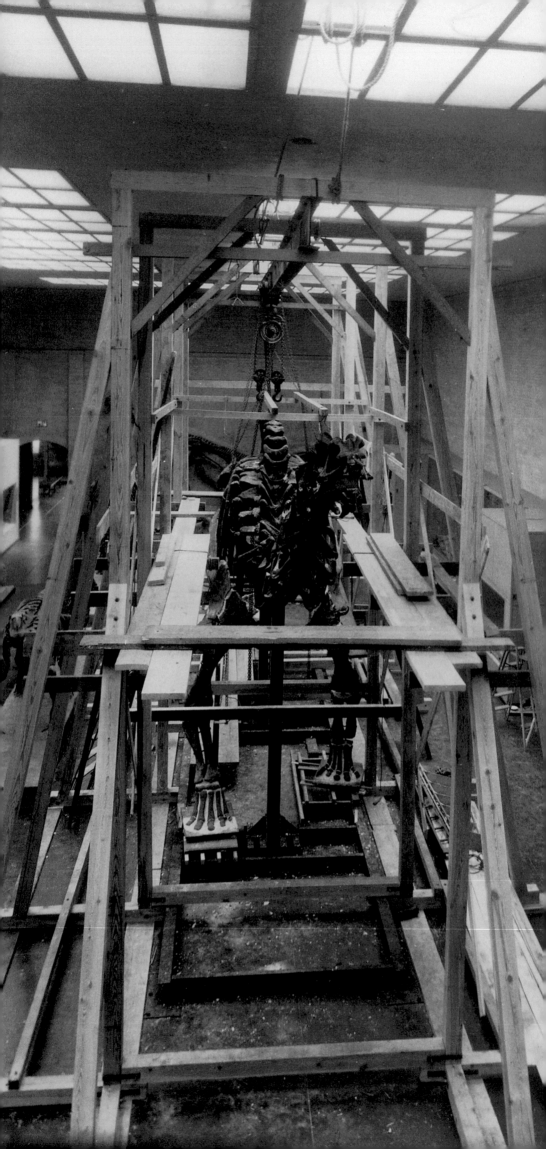

Introduction

The Peabody Museum of Natural History at Yale University was founded in 1866 with a gift from philanthropist George Peabody, at the urging of his nephew Othniel Charles Marsh, Yale's first professor of paleontology. The Peabody's collections were housed from 1876 to 1917 in its first building on High Street, in New Haven, until that site was needed for Yale construction projects. Although delayed by World War I, a second Peabody Museum was built, the current French Gothic-inspired building on Whitney Avenue.

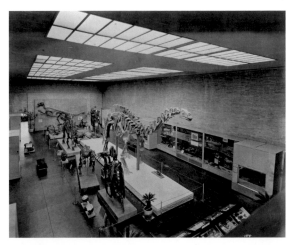

When the new building opened at the end of 1925 (the year of Tennessee *v.* John Scopes), the first floor exhibitions told the story of animal evolution. For the lower vertebrate exhibits, architect Charles Z. Klauder had been asked to design a room large enough to house the giant reptiles that O. C. Marsh and his bone hunters had collected in the American West in the 19th century—*Stegosaurus, Edmontosaurus,* and *Apatosaurus* (formerly "*Brontosaurus*"). The Great Hall was the result.

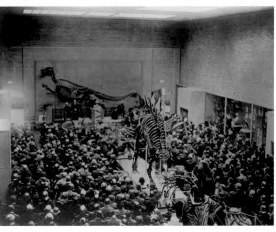

The populating of the Great Hall with these early exhibits was completed by Commencement in June 1931. Most of the displays have long since changed, and some of the large animals have moved around from time to time—but not *Apatosaurus*, which is mounted on a steel framework attached to a web of steel that is permanently anchored to the floor. One major defect had not been foreseen by the planners, however—the walls were gray, the floor was gray, the fossils were gray, and so, too, the room was gray.

Then, in 1942, Rudy Zallinger, a senior at Yale's School of the Fine Arts, took a job illustrating seaweed for the Peabody's director Albert Parr. "Albert had this wall in the Museum and a lot of gray bones," Zallinger recalled. "He thought it ought to be spruced up. Lewis York, head of the art school, suggested that I paint it. When we got into it, we

ABOVE: The Great Hall in the 1930s before *The Age of Reptiles* mural was painted.

BELOW: The dedication exercises of the Peabody Museum of Natural History on December 29, 1925, were attended by some 800 people, including members of eight scientific societies—the Geological Society of America, Paleontological Society, Mineralogical Society, American Anthropological Association, American Society of Naturalists, American Society of Zoologists, Society of Economic Geologists, and New England Conference of American Association of Museums—whose annual meetings had been specially scheduled for the occasion.

OPPOSITE: The *Apatosaurus* skeleton, still without its skull, being mounted in the Great Hall. Note the skylights, which were the only source of light in the hall. The supporting steel framework anchoring the mount to the floor is visible in the foreground.

Rudolph Zallinger in front of the Cretaceous section of *The Age of Reptiles* at the unveiling of the (not yet finished) mural on October 18, 1946.

saw an opportunity to do something definitive." It was Zallinger's idea to do one long mural instead of separate panels. Zallinger created *The Age of Reptiles* in less than five years, from 1942 to 1947. This included 18 months of preliminary work that started with a crash course in comparative anatomy and on the animal and plant life of the distant past. His teachers were Yale's Richard Swann Lull ("he was approaching 80"), G. Edward Lewis, and George Wieland, and Harvard's Alfred Romer, among others. After producing a preliminary version on a small panel, Zallinger spent three-and-one-half years actually painting the entire east wall of the Great Hall.

One of the largest natural history murals in the world, *The Age of Reptiles* measures 110 feet (33.5 meters) and rises to a height of 16 feet (4.9 meters). The mural was refurbished by Zallinger in 1983 to repair water damage from a roof leak. In 1988, with a new lighting system that improved viewing and reduced exposure to ultraviolet light, the difficult task of directly photographing the mural was accomplished for the first time, for a guide published by Harry N. Abrams, Inc. An air handling system was installed in 2000 to better control humidity and temperature in the Great Hall.

Times change, exhibits change, but it is safe to say that *The Age of Reptiles* will remain as long as the current Peabody Museum building stands.

Rudolph Zallinger

Rudolph Franz Zallinger was born on November 12, 1919, in Irkutsk, Siberia, Russia. His father Franz, an Austrian soldier captured in World War I by the Russians, during his captivity met and married Marie Koncheravich, the daughter of a Polish civil engineer working on the Trans-Siberian Railway. When their son was nine months old, the Zallingers began a harrowing emigration eastward, eventually reaching the United States and settling in Seattle, Washington, in 1924.

Rudy Zallinger in 1989.

Zallinger's childhood was steeped in art, from his artist father, in school, and from private teachers. At 17 he was urged to enroll at Yale by John Butler, a visiting artist from Virginia. That year Zallinger entered Yale University's School of the Fine Arts. With merit scholarships every semester after his first, in 1942 he completed his Bachelor of Fine Arts in Painting.

While still a senior at the art school, Zallinger began illustrating marine algae for oceanographer Albert E. Parr, who was then director (1938–1942) of the Yale Peabody Museum. According to scholar, educator, and curator Carl O. Dunbar, Parr recognized "uncommon talent" in the young artist. Dunbar succeeded Parr as director (1942–1959), and it was Dunbar's leadership that guided both of the Peabody's great murals—*The Age of Reptiles* and *The Age of Mammals*—to completion (Zallinger's portrait of Dunbar hangs in the Peabody's administrative offices today). Zallinger worked on *The Age of Reptiles* mural from April 1942 to June 1947. In 1949 he received a Pulitzer award in recognition of this outstanding achievement.

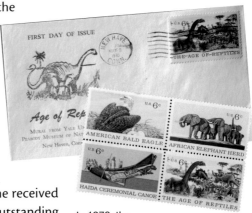

In 1970, the United States Postal Service issued a first class stamp depicting a detail of *The Age of Reptiles* mural, the first U.S. stamp on the subject of paleontology.

During this time Zallinger also taught art at Yale, but in 1950 he went back to Seattle to work as a freelance artist. After the mural was brought to the attention of *Life* Magazine's editors by former New Haven mayor Richard C. Lee (at that time the head of Yale's News Bureau), in November 1952, Zallinger received word that *Life* wanted to use the mural for its "The World We Live In" series.

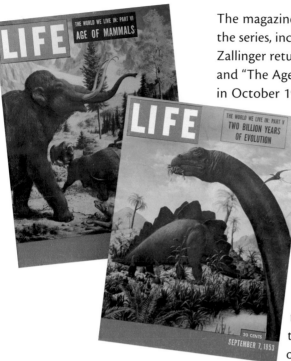

Zallinger's published illustrations for "The World We Live In" series. (Courtesy of Time-Life, Inc. Used with permission.)

The magazine also commissioned new works for the series, including one on prehistoric mammals. Zallinger returned to Yale as a Fellow in Geology, and "The Age of Mammals" was published in *Life* in October 1953. It was not until the 1960s that funding allowed this illustration to become what is now *The Age of Mammals* mural on the south wall of the Hall of Mammalian Evolution at the Yale Peabody Museum. Zallinger completed this second *fresco secco* mural in 1967, on his 48th birthday.

Zallinger's paintings are in the permanent collections of the Seattle Art Museum, Yale University, and in many private and corporate collections. After 1961 he was on the faculty of the Hartford Art School of the University of Hartford, and taught courses at the Paier School of Art in Hamden, Connecticut. In 1971 he received a Master of Fine Arts in Painting from Yale. In addition to the Pulitzer award, among his many honors in his long and distinguished career as an educator, muralist, and painter were honorable mention for the Prix-de-Rome in 1941, an honorary Doctor of Fine Arts degree from the University of New Haven in 1980, and Yale's Addison Emery Verrill Medal in 1980.

Zallinger met and married the painter Jean F. Day while both were art students at Yale, and had three children. Rudolph F. Zallinger passed away on August 1, 1995, at the age of 75.

Portrait of Carl O. Dunbar painted by Rudolph Zallinger.

The Addison Emery Verrill Medal

Rudy Zallinger was the first non-scientist to receive the Verrill Medal, awarded from time to time by the curators of the Yale Peabody Museum "for outstanding contributions to the field of natural history." Presented to him by A. Bartlett Giamatti, then president of Yale University, at a ceremony in the Great Hall on February 29, 1980, the citation reads:

> Rudolph Franz Zallinger, artist and teacher, your great natural history murals at the Peabody Museum are a fusion of scientific accuracy and artistic genius. Guided by your own diligent research and painstaking collaboration with scientists, your imagination has allowed us a glimpse into past worlds no human eye ever witnessed. It was your innovation to blend the static frames of successive geologic ages into grand panoramas that sweep through time, capturing the dynamic force of life as it evolved.

The Addison Emery Verrill Medal was established in 1959 to honor noted zoologist and Yale scientist Addison Emery Verrill, known worldwide for his studies of starfish, squids, corals, and other marine animals. Verrill was also a skillful artist, who, according to his successor as curator Wesley R. Coe, "had such powers of visualization that with a stubby bit of pencil he could make a satisfactory drawing of almost any species he had ever seen." The front of the medal bears Professor Verrill's profile, while the reverse depicts a starfish, representative of his pioneering work in invertebrate zoology.

The Verrill Medal was the idea of Peabody Museum Director S. Dillon Ripley (1959–1964), later Secretary of the Smithsonian Institution, "to honor some signal practitioner in the arts of natural history and natural science." The medal was designed by Robert W. White and struck by the Medallic Art Company.

In 1997, in partnership with the City of New Haven and S. N. Phelps & Company, the Yale Peabody Museum placed a 72-by-36-foot (22-by-11-meter) detail of the Jurassic section of *The Age of Reptiles* on an oil tank at New Haven Harbor. The mural image was reproduced by the 3M Corporation, which developed an adhesive especially for the project. About 60 feet (more than 18 meters) off the ground, it is seen by the more than 100,000 commuters who cross New Haven's Pearl Harbor Memorial Bridge daily.

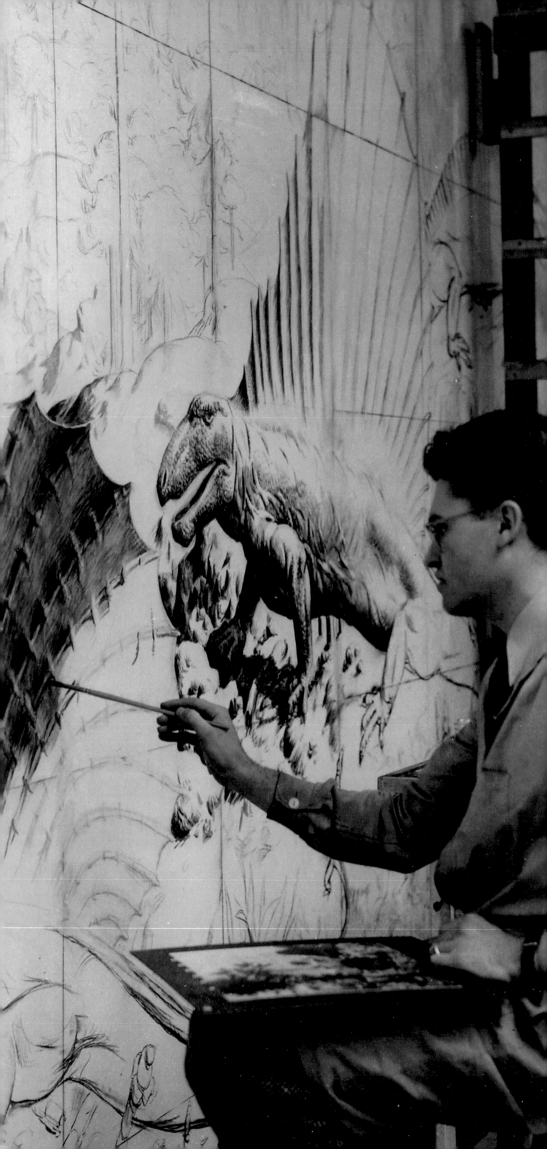

Creating the Mural

Rudolph F. Zallinger

In early January 1942, during my last year at the Yale School of the Fine Arts, I had the good fortune to be offered some illustration work. (This offer was especially providential, since I was newly married to classmate Jean Day and we were typically strapped for funds.) The bearer of my good fortune was Dr. Albert E. Parr, then director of the Yale Peabody Museum of Natural History.

Parr had been unhappy with the appearance of the Great Hall of the Museum, which he thought resembled a dismal, barren cavern devoid of color, and he therefore asked Lewis E. York, one of my professors at art school, if he would recommend an artist who could paint it. Their discussion evidently went something like this:

> *Parr:* There is this large wall space, which would be suitable for applying some sort of decoration, probably a series of portrayals of beasts represented by skeletons in the hall— or some such thing. Lewis, do you know any-one who could undertake such a work?
> *York:* Sure. And, you already know him. It's Rudy. He has been doing all those seaweed drawings for you.

Some time after that conversation, I presented a batch of my latest works to the curators of the Pea-body Museum to demonstrate my ability to com-prehend and synthesize data and create convincing images. Naturally, the sample works involved subject matter other than ancient lizards and extinct flora. The curriculum at the Yale School of the Fine Arts did not include a course in the painting of dinosaurs. Those who reviewed the evidence were apparently satisfied that the project could move forward, wher-ever it led. As of March 1, 1942, I was appointed to the staff of the Peabody Museum to devote myself exclusively to the wallpainting project.

In natural history museums, the traditional convention for painted restorations of ancient ani-mals made use of a single animal or a group of one or perhaps a few species, which strictly observed a geological time frame and location. Dr. Parr and others talked about painting a series of pictures showing dinosaurs with other animal and plant life that would cover the east wall of the Great Hall and would help the public envision as living animals the

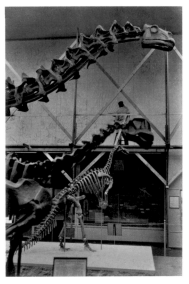

Zallinger creating the preliminary line drawing of *Dimetrodon* in charcoal, late 1943. Note, at the top, the old, in-correct skull originally mounted on the *Apatosaurus*.

OPPOSITE: Working from a sketch in his lap, Zallinger begins the preliminary underpainting for *Edaphosaurus*, late 1944.

The Great Hall at a very early stage, sometime in late 1924. Peabody Museum Director (1922–1938) Richard Swann Lull contemplates developments in the exhibit cases while *Stegosaurus* temporarily rules the wide open spaces in the center of the room.

beasts that were represented by skeletons in the hall.

I recall pondering over that long brick wall and wondering how it could be divided into panels—separate framed panels. That format violated one of the basic tenets of mural design in that architecturally it seemed incongruous. Breaking up that great expanse in this large public space measuring 110 feet in length, 55 feet in width, and 26 feet in height (minus the 10 feet allocated to exhibit cases) clearly posed a problem. However, protesting against convention was not enough. The appropriateness of an alternative had to be proved or disproved. Out of my discussions with my new collaborators, especially with Dr. G. Edward Lewis, who was the curator of vertebrate paleontology, I ultimately proposed a different concept, that of using the whole available wall— 110 feet by 16 feet of it—for a "panorama of time," effecting a symbolic reference to the evolutionary history of the earth's life up to the emergence of dinosaurs and through their domination of the Mesozoic Era. After some deliberation, this format was adopted, and my collaborators—mainly Dr. Lewis and Dr. George R. Wieland—proceeded to submit me to an unparalleled crash course in the various

Zallinger's earliest sketch of the proposed mural. Pencil on paper, 28.5 x 7.75 inches, 1943.

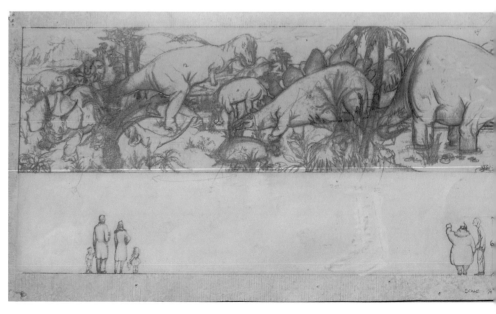

disciplines involved, principally vertebrate paleontology and paleobotany.

The process of creating the mural involved, first, the development of a working drawing or cartoon, in which the particulars of the elements and other design issues were gradually formulated, carrying into execution the enormous amount of data that I was beginning to sort out in my mind. This drawing consisted of a 10-foot-long sheet of heavyweight, 100% rag paper whose ends were attached to cardboard tubes four inches in diameter. In operation, it resembled a Chinese scroll. The device was portable, and by rolling or unrolling, one gained access to individual sections of the drawing as needed.

Many arrangements were tried and revised and revamped as the compositional format was being developed. Large foreground trees served as symbolic markers of boundaries between the geologic periods. The painting, which represents an evolutionary time span of more than 300 million years, thus gives some suggestion of epochs separated in time. Because the main entrance to the hall is at the south end—near the right side of the mural—and because of the time sequence in which the Peabody's fossils are arranged, the chronology of the subject matter moves from right to left rather than in the customary direction.

Zallinger's pigments (among them chromium oxide, iron oxide, and cobalt), his sable brushes, and a jar of casein, along with the "palette," used in the painting of the murals at the Peabody Museum.

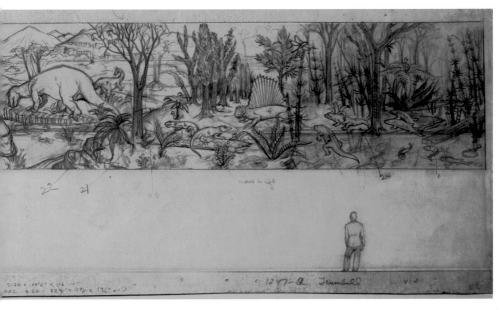

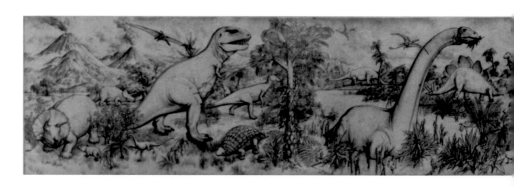

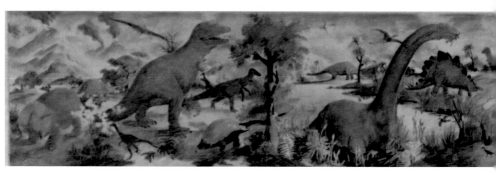

ABOVE: Zallinger's working drawing or "cartoon" on heavyweight, 100% rag paper. Pencil on paper, 1943.

BELOW: The shaded sketch for the fresco, showing the relative light and dark values. Pencil and charcoal on paper, 1943.

Adherence to scientific correctness in all respects was the goal of every participant, particularly as we became increasingly aware of the opportunity to create a definitive work. I respected the authority of my collaborators with regard to factual data and information; they avoided comments or criticism on aesthetic, artistic matters.

My experience in comparative anatomy was extremely limited at the beginning of the project. However, during my five-year arts course at Yale, the study of human forms was taught in a manner that promoted a deeply analytical approach to constructive anatomy. Consequently, I crossed the bridge to the structure of amphibians, reptiles, and other life forms with a well-buttressed hope of positive results. For example, Dr. Richard Swann Lull, at one time during his long, distinguished career as a vertebrate paleontologist, had prepared a flayed, superficial muscular rendering of a typical biped and one of the duckbills of the Cretaceous. Together we managed to produce similar renderings for quadrupeds.

This stage of the work took about six months, resulting finally in a fairly determinate image in pencil, measuring 12 inches in height and 82 ½ inches in width at the scale of three-quarters inch to the foot.

This pencil cartoon was a preamble to the next step, namely the preparation of a gesso panel of the

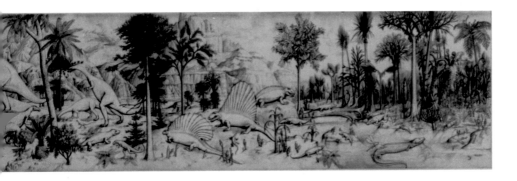

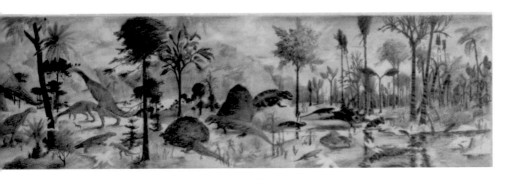

same size for the purpose of creating a full-color, fully realized painting as a model for the east wall. This panel would be executed in egg tempera, following the imperatives of the 15th century painter and chronicler Cennino Cennini for the proper preparation of a *fresco secco*. There is a close relationship between these techniques, egg tempera functioning naturally on a smaller scale and the casein-glue-tempered *fresco secco* better suited to larger sizes.

I completed the egg tempera panel in October 1943. Several months earlier, the wall had been plastered in preparation for the painting. Briefly, sheets of steel lath were riveted to the brick wall, a grout coat of plaster about an inch thick was applied, and over this a filler coat a bit less thick was spread. The final surface coat consisted of a slaked-lime and river-sand mix applied smoothly as a skim coat of an average one-quarter-inch thickness. Lime plaster is more stable; it does not contract and expand to the extent that gypsum plasters do.

After the wall had been allowed to cure, it was measured. The curing had been timed to coincide with the completion of the full-color panel. I began my work on the actual wall in October 1943. Using black-and-white photographs mounted on hardboard and gridded into one-and-one-half-inch squares as a guide for scale, I then drew a grid on the wall, dividing it into two-foot squares. In other

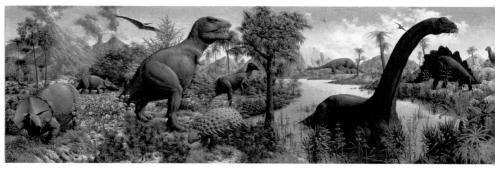

The preliminary small-scale painting, or model, of *The Age of Reptiles*. Egg tempera, 1943. (© 1966, 1975, 1985, 1989, Peabody Museum of Natural History, Yale University.)

A comparison, below, of the prehistoric insect *Meganeuropsis* as depicted in the tempera model (top) and the mural in the Great Hall (bottom) is an example of how Zallinger refined his treatment of the animals and plants in the final painting.

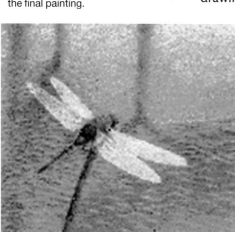

words, a one-and-one-half-inch square on the photograph equaled a two-foot square on the wall. The scaffolding consisted of a planked platform six feet wide at the top of the wall cases; this ran the full 110 feet of the east wall. A movable wooden carriage with rather primitive variable height capacities provided essential access.

This movable rig was pushed over to the far right end of the hall, and at the end of October 1943 I mounted to the top platform to start a line-drawing version of the whole composition. Vividly etched in my memory is my trepidation as I scanned that endless wall while holding a slender stick of charcoal in my hand, about to begin my work with a tool seemingly so inadequate to the task. However, I regained composure and began what turned out to be a three-and-one-half-year project.

My working schedule consisted of teaching two days a week at the Yale School of the Fine Arts, with the rest of the time devoted to work on the mural. The diagramming and line drawing went along rather smoothly. They enabled me to adjust to the scale and size—arm swings compared to finger movements, the confronting of an area of 1,760 square feet! I completed this linear phase about five months later.

Next was the development of a tone-modulated monochrome underpainting, rendered with a mix of black and burnt umber pigments tempered by a 5% solution of casein glue (chemically similar to the cheese-and-lime glue of Renaissance times). All the forms set down at that stage were deliberately overmodeled so that traces would later show through the over-painted layering of colors. These first paint

films were restricted to a medium tonality for the light sides of forms and a matrix coating for the darker parts.

The later phases, most time-consuming because of their complexities, involved the elaboration of modulations of tones, lines, and shapes in order to achieve the intended illusions—the final three-dimensional appearance of the work.

This technique, called *fresco secco* (from the Italian *fresco*, plaster, and *secco*, dry) is not often practiced today for many reasons, among them the difficulty of painting at the site in the current scheme of things. Moreover, there are very few painters who have acquired the competence to execute the process and equally few painters in egg tempera able to carry out the technical preparation for *fresco secco*. All this is most regrettable, because the attributes of this centuries-old form of mural painting—with its resulting delineating character, its capacities to feature the pure essences of pigment individualities—are all desirable qualities. Furthermore, this technique provides durability second only to *buon fresco*, in which pigments are infused into wet plaster, and was most notably practiced by Michelangelo in the Sistine Chapel. The secco painting allows for intricacies of detail not possible in the other technique—a deciding factor in its selection.

During the three-and-one-half years I painted on the wall, the Great Hall was always open. Students, colleagues, and the general public thus had a rare opportunity to witness the gradual development of a large painting, created by means of a technique uncommon in the 20th century. I completed the painting on June 6, 1947.

My mentor for technical information and aesthetic concerns was my long-time professor, faculty colleague, and friend Lewis Edwin York, chairman of the department of painting at the Yale School

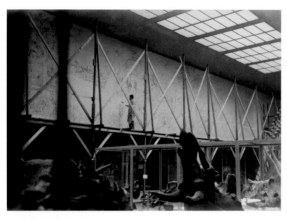

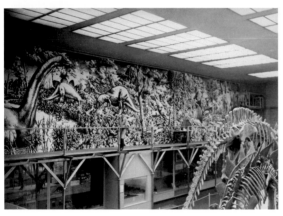

of the Fine Arts (1937–1950). His mentor in these matters was Daniel Varney Thompson, who was the primary translator of Cennino Cennini's 15th century tome about "the practice of the art." Thompson had been in England while the mural was being developed. I will forever recall the day, when the painting was nearing completion, that York brought this living legend, Thompson, into the Great Hall and I was privileged to meet and talk to the man whom I had revered for so long.

Professor York later told me that Thompson had stated, "That wall is the most important one since the 15th century"—debatable, of course, but, considering the source, most gratifying.

ABOVE: Zallinger developing the charcoal drawing for the fresco from preliminary sketches, 1944.

BELOW: The completed underpainting, whose bold forms will remain visible even after overmodeling with additional layers of paint, 1944–1945.

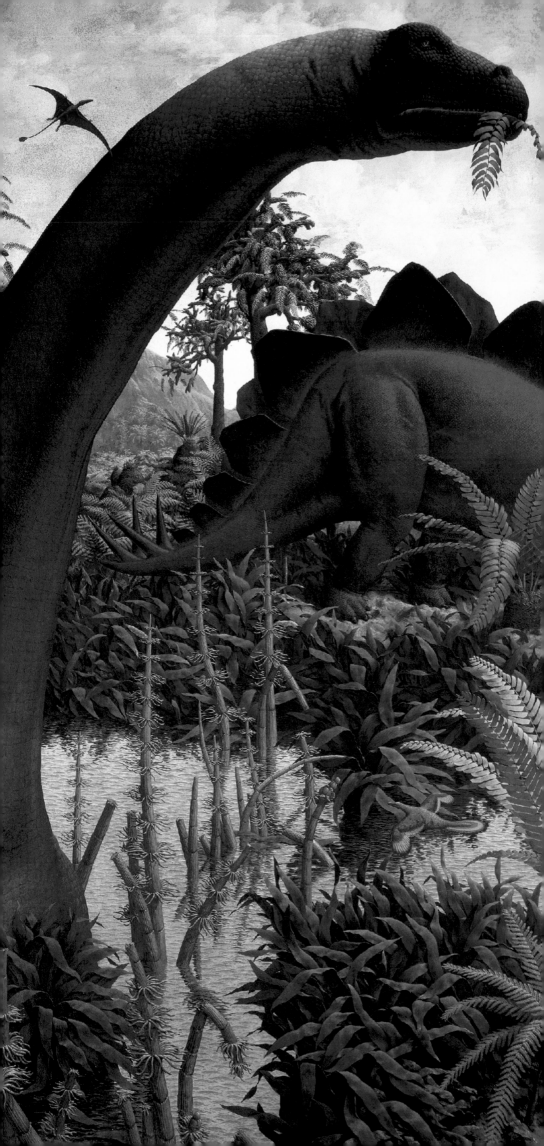

THE "BIG FIVE" MASS EXTINCTIONS OF THE PHANEROZOIC

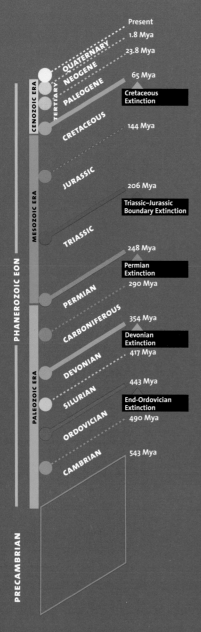

Present
1.8 Mya
23.8 Mya
65 Mya

Cretaceous Extinction

144 Mya

206 Mya

Triassic–Jurassic Boundary Extinction

248 Mya

Permian Extinction

290 Mya

354 Mya

Devonian Extinction

417 Mya

443 Mya

End-Ordovician Extinction

490 Mya

543 Mya

QUATERNARY
NEOGENE
PALEOGENE
CRETACEOUS
JURASSIC
TRIASSIC
PERMIAN
CARBONIFEROUS
DEVONIAN
SILURIAN
ORDOVICIAN
CAMBRIAN

CENOZOIC ERA
TERTIARY
MESOZOIC ERA
PALEOZOIC ERA
PHANEROZOIC EON
PRECAMBRIAN

The geologic ages given here and on the accompanying poster are adapted from the Geological Society of America (GSA) 1999 Geologic Time Scale, A. R. Palmer and J. Geissman, compilers. See www.geosociety.org.

Mya = Million years ago

The time scale of earth history is based on major geologic events, and on the origination and extinction of species. The oldest known rocks have been dated to about 4 billion years ago, and the earth is thought to be 4.54 billion years old. The early single-celled organisms of the Precambrian gave way to the Phanerozoic Eon, which is marked by the evolution and diversification of multicellular life. The three large eras of the Phanerozoic are the PALEOZOIC, MESOZOIC, and CENOZOIC. The oldest segment is the PALEOZOIC, the Age of Ancient Life, when there was abundant life in the oceans, such as trilobites, brachiopods, sea scorpions, rugose and tabulate corals, and cephalopods like nautiloids and ammonoids. Throughout the PALEOZOIC there was a gradual colonization of land by plants and animals.

During the MESOZOIC, known as the Age of Dinosaurs, reptiles dominated on land, and the first birds appeared. The more primitive PALEOZOIC plants like cycads and ferns on land were joined by angiosperms (flowering plants), which began to diversify during the CRETACEOUS. Although present, mammals were not nearly as dominant as they became in the CENOZOIC, the Age of Mammals. We are living in the Holocene Epoch of the CENOZOIC Era.

Of the major extinctions of the past, the most severe was at the end of the PERMIAN Period, when up to 90% of marine animals became extinct. The PERMIAN extinction is believed to have resulted from a combination of climate change, large-scale volcanism, and plate tectonics.

Dinosaurs suffered a major extinction event at the Cretaceous–Tertiary boundary (known as the K/T boundary, which is also the boundary between the MESOZOIC and CENOZOIC eras). The 65-million-year-old Chicxulub Crater, on Mexico's Yucatán Peninsula, is evidence of the impact of an asteroid 6 miles (10 kilometers) in diameter, which would have created a worldwide ecological catastrophe.

Life and Landscape in the Mural

The lasting power and eloquence of Rudolph Zallinger's world-renowned mural, *The Age of Reptiles*, is a tribute to Zallinger's foresight and artistry, and to the care and dedication of the scientists that he consulted. It is both a significant work of illustrative art and a historically important scientific document that in its time transformed the contemporary knowledge of ancient life into realistic images. Although scientific understanding is always improving and our vision of natural history has changed since Zallinger applied the last brush stroke to his masterwork in June 1947, the importance of the mural as a historical document remains. As a work of art, *The Age of Reptiles* represents a complete and final rendering of the artist's vision at the time of its completion.

Both a menagerie and a botanical garden, Zallinger's mural portrays a chapter of earth history spanning almost 300 million years, a composite of many moments during the time span that it portrays. As a result of new paleontological data and revised ideas about what happened during the Paleozoic and Mesozoic, *The Age of Reptiles* differs from current scientific thinking.

Why not revise *The Age of Reptiles* and paint in the updated scientific knowledge? To do so would violate the mural as an independent work of art and destroy the integrity of Rudolph Zallinger's original vision. Furthermore, the mural is a statement of the best scientific understanding of earth's prehistory at the time of its completion. Because scientific knowledge is always progressing, even an updated mural would not stay accurate for long.

The mural's five prominent, solitary trees visually separate the panoramic scene into six periods of **geologic time**. Reading the mural from the oldest period at the right to the most recent at the left, these are the Devonian, Carboniferous, and Permian Periods of the Paleozoic Era, and the Triassic, Jurassic, and Cretaceous Periods of the Mesozoic Era. Because the plants and animals depicted in *The Age of Reptiles* represent more than 300 million years of evolutionary history, even those organisms shown in the mural in a single geologic time period were not necessarily contemporaries. Zallinger's mural presents an artistic illustration of the continuously changing life of the Paleozoic and Mesozoic eras.

The small illustrations of the mural's animals and plants that accompany the side bars in this book are keyed to the animals and plants depicted in the mural. Use these drawings to locate them on the poster at the back of this guide, or when studying *The Age of Reptiles* in the Yale Peabody Museum's Great Hall.

See Zallinger's account of his process in "Creating the Mural," on page 7.

For more on the mural's place in the history of art, see Vincent Scully's "*The Age of Reptiles* as a Work of Art," on page 63.

Certain fossils that are characteristic of geologic layers, or strata, where they are found are used to date the boundaries of the geologic timescale. These index fossils, such as *Dictyonema retiforme* (YPM 34922), which is found in rocks that are Middle Ordovician in age, should be easily distinguished from other **taxa**. Good index fossils are species that had short stratigraphic range and broad geographic distribution.

Terms in **bold** are defined in the glossary.

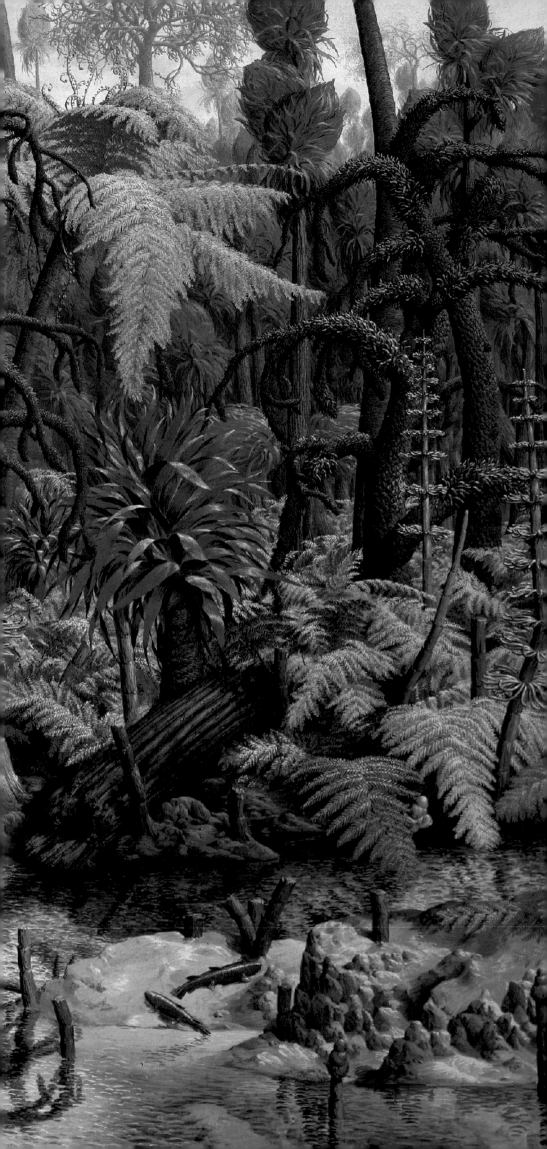

Enter the Actors: The Devonian Period

On a small river sandbar in its lower right-hand corner, the mural first picks up the thread of pre-history during the Late Devonian Period, about 362 million years ago. In some ways, Devonian times were like the present: rains fell and river channels carried sediment-laden runoff to the ever-restless seas. Then, as now, the earth's rigid outer crust, the **lithosphere**, floated atop the deeper, fluid mantle, the **asthenosphere**. Volcanoes erupted at the surface and earthquakes accompanied the mountain building that results from intense collisions among the great rock plates that make up the crust. If we could have looked down from space at our planet, we would not have seen the familiar continents and oceans of today. These were to gradually emerge about 150 million years later from the drift and rearrangement of plates that were then far from their present locations.

There would have been little to suggest, at the start of the Devonian, that it was to be a dynamic period of **evolution** for terrestrial life. The scene that greeted the eye would have shown a largely barren earth of exposed rock covered by no plants more advanced than lichens and **algal** and **bryophytic** plants, except along the banks and shores of bodies of water. However, a detailed examination of the weathered surface would have revealed the activity of many types of microorganisms.

The streams and sheltered coastlines of this landscape were the true beachheads for the evolution of terrestrial plants and animals. Since the completion of *The Age of Reptiles* mural we have learned a great deal about the earliest terrestrial plant ecosystems, so it would now be possible to render the small, primitive Devonian plants in the extreme bottom right of the mural in more detail.

Humble as they were, however, these seemingly primitive forms had already overcome the fundamental barriers that confined most of their algal ancestors to an aquatic mode of life. They were covered with **cuticle**, a waxy, water-repellent coating that helps keep plants from drying out. This covering was pierced by **stomata**, small pores that allow the plant to control the exchange of the gases that are necessary for **photosynthesis** and **respiration**. The first land plants also had developed small, fibrous outgrowths, not yet roots, that gave them a tenuous hold on the soils on which they grew. An-

The very narrow segment of the mural at the right margin was meant to reconstruct a Late Devonian landscape based on the best information available at the time the painting was completed. Geologic evidence of fossil plants, freshwater **vertebrates**, and sedimentary rocks suggest that certain regions were low-lying coastal plains with dense fern and tree fern forests transected by sluggish, meandering streams. Among the inhabitants of these environments were the ancestors of the many land animals of later times. However, in this opening scene of the mural, only the animals are properly placed in the Devonian Period; the plants in the middle and background did not actually appear until the Carboniferous Period.

Paleobotanists generally agree that plant life began in aquatic environments, and that terrestrial forms are a result of a slow migration of plants from water to progressively drier land. The transition occurred first during the early Paleozoic Era, probably in the Silurian Period, or perhaps even earlier. These earliest land plants (not represented in the mural) were simple, spore-producing forms. Once on land, they spread rapidly and by the Devonian Period several major groups had evolved. Fern relatives, club moss relatives, and horsetails were especially abundant.

This stromatolite (YPM 411) from the Precambrian of western Ontario, Canada, shows a fossilized banded algal mat embedded in a silica matrix.

other important innovation was the introduction of hollow cells to carry water and nutrients from the soil up into the aerial parts of the plant. This **vascular system**, largely unnecessary for submerged plants or for low land plants that remained close to moist surfaces, was essential before land plants could grow taller than waist height.

With all the apparent difficulties of the struggle to cope with the terrestrial environment, why would plants have been drawn landward at all?

One answer to this puzzle is to be found in the search for sunlight. Sunlight provides the energy that most plants use to fix carbon into the sugars that power their **metabolism**. The land surface of the earth, then, represented a tremendous untapped energy resource for plant life; because the atmosphere is much less dense than water, the amount of energy available at the surface is far higher than in all but the shallowest and clearest aquatic environments. **Adaptations** for life on land granted these early plants unprecedented access to sunlight and introduced them to unoccupied ecological **niches**. This triggered an **adaptive radiation** wherein the open niches began to be filled with countless **species** of land plants.

All of this evolution, some 50 or 60 million of years of it, produced the small, leafless **herbaceous** plants suggested in the lower right corner of the mural. Lacking all but the most rudimentary means of support and without the capacity to increase in girth, these pioneers were seldom able to grow to more than three or four feet (about one meter) in height before they fell over. Yet a major milestone in evolution had been achieved, for with the advent of land plants, a stable source of food was at last anchored on terra firma, and arthropods and vertebrates could begin to radiate inland.

Natural selection, a theory that was introduced by Charles Darwin in 1859 in his *On the Origin of Species*, is the process of evolutionary change wherein advantageous, **heritable** traits become more prevalent in a population because of the increased likelihood that the organisms that have them will survive and reproduce. Yale professor Othniel Charles Marsh was a pioneer in the study of fossil vertebrates and North America's first professor of **paleontology**. Marsh was a major contributor to the debate about evolution and met Darwin on a trip to Europe in the 1860s. Above is Darwin's 1880 letter to Marsh commending his "work…on the many fossil animals of N. America [that] has afforded the best support to the theory of evolution." Also shown is an illustration of an imaginary "Eohomo" riding on an early horse, *Eohippus*, drawn by T. H. Huxley, a prominent supporter of Darwin's theory. Huxley drew the cartoon when he visited Marsh in New Haven in 1876. (Portrait of O.C. Marsh by Thomas LeClear.)

In the Middle Devonian Period, a second major innovation, the ability of the plant stem to grow in girth indefinitely, allowed plants to grow to the height of trees, and presented land animals with new food sources and with a deep, complex canopy that provided many new niches in which to live. Using an array of light-collecting leaves, which evolved at about the same time in several lines of plants, plants could now process a column of sunlight reaching over 100 feet (over 30 meters) in height. An early tree fern, **Psaronius**, with a tall trunk and fernlike fronds, is shown on the right-hand side of the mural.

Large treelike forms such as **Psaronius** (saw-RONE-i-us) and the more herbaceous ferns were prominent in Carboniferous land-scapes (here it is mistakenly depicted in the Devonian Period of the mural). *Psaronius* could have exceeded 49 feet (more than 15 meters) in height, and characteristically had an unbranched trunk with a crown of large, compound fronds that perhaps were more than three feet (one meter) in length.

To realize just how significant these adaptations were, we should look at photosynthesis in the aquatic environment. In a body of water, plants can only exist in the shallows. As a result, although oceans cover 70% of the earth's surface, oceanic photosynthesis probably contributes less carbon to the biosphere than land-based photosynthesis.

The appearance and spread of tall, vascular plants over at least the lowland portions of the earth caused a rapid increase in the supply of food on land, and the rush of animals to exploit this new resource began. The evolutionary drama represented by the mural thus takes place, fittingly, in a theater, with its columns and roof beams of green plants already firmly in place. It is important, however, not to forget that this green world is not merely the setting, but a principal player in the unfolding drama of life on land.

Polished cross section of the fossilized stem of the Carboniferous *Psaronius* sp. (YPM 53178), from Saxony, Germany.

The vertebrate actors of the opening scenes in this play of life were a diverse lot of peculiar-looking creatures that lived in the marshy lowlands of the Devonian. Lurking beneath the surface of the rippled bayou is a fish that goes by the name **Cheirolepis**. *Cheirolepis* was an early member of the Actinopterygii, that group of fish with bony rays in their fins. Most of the fish familiar to us today (trout, salmon, tuna, marlin, and others) are also **actinopterygians**. The distribution and quantity of *Cheirolepis* fossils suggests that this animal was both widespread and abundant by the Late Devonian Period.

Cheirolepis (kie-row-LEEP-us) is an early example of an actinopterygian, a ray-finned fish. The earliest robust evidence for actinopterygians is from the Devonian Period. Today, a group of ray-finned fish called **teleosts** is the dominant group of aquatic vertebrates, as they account for approximately half of the known diversity of all vertebrate species. *Cheirolepis* was unlike today's teleosts in that it had an asymmetrical tail, a primitive feature that it retained from the ancestor it had in common with sharks.

The small, fish-like creatures wriggling up the sandbar in midstream are among the earliest sarcopteryg- ians. Fossil skulls of **Eusthenopteron** (use-then-OP-tair-on) have nasal pas- sages more similar to those of land- dwelling animals than to those of fish. These passages, which open into the mouth, suggest that *Eusthenopteron* used lungs to breathe air. The fins of *Eusthenopteron* feature the same bone elements in the same arrangement as in the arms and legs of all limbed tetra- pods, including humans.

During the Late Devonian, one group of aquatic sarcopterygians gradually adapted to life on land. Today, the living members of this group, Tetrapoda (meaning "four feet"), include all land- dwelling, burrowing and flying vertebrates, in addition to second- arily aquatic verte- brates such as whales and dolphins. The 2004 discovery of *Tiktaalik roseae* on Ellesmere Island, Arctic Canada, unlocks many of the mysteries of the evolutionary and ecological transition from aquatic vertebrates with fins to land-dwelling vertebrates with limbs. *Tiktaalik's* combination of aquatic and terrestrial features reflects this time of transition. Although it has scales and fins like a fully aquatic animal, it also has a mobile neck, and body-sup- porting ribs and limb bones like a fully terrestrial animal. *Tiktaalik* likely lived in shallow streams and ponds and had the ability to pull itself out of the water and onto the shore. From these humble beginnings, vertebrates radi- ated into countless new niches, giving rise to forms as disparate as snakes, hummingbirds, and human beings. (© T. Daeschler/VIREO. Courtesy of the Academy of Natural Sciences, Philadelphia.)

Swampy landscapes such as the one depicted in the right-hand section of the mural set the stage for the terrestrial success of **sarcopterygians**, the lobe-finned **lineage** of vertebrates that led to air- breathing, land-dwelling **tetrapods**. *Eusthenop- teron* likely used its muscular, bony fins to move around in shallow, muddy pools of water. It may even have been able to pull itself out of the water, thereby making it one of the earliest vertebrate pil- grims into the terrestrial realm.

LAND OR SEA?

The Age of Reptiles shows life that inhabited the land. Throughout geologic time, however, most animals lived in the marine realm, in the earth's saltwater oceans and seas.

There is a reason many creatures prefer marine habitats to terrestrial ones—it is easy living! Water provides a more stable environment than land. On land, animals need survival strategies to deal with changes in climate (such as seasonal humidity and dryness) and daily temperatures (daytime heat alternating with cold nights), and are constantly faced with unreliable access to water and nutrients. In contrast, large bodies of water change temperature slowly, so organisms don't need defenses to deal with fluctuations. Marine habitats also allow the easy exchange of nutrients and waste products between organisms and the surrounding environment.

Salt water also provides buoyancy. This is particularly useful to animals that do not have bones. Although some invertebrates, such as corals, bivalves, brachiopods, and marine snails, have shells or frameworks made of minerals like calcite, others like octopuses, squids, and sea sponges rely on the supportive quality of buoyant salt water. With a terrestrial lifestyle both animals and plants need different strategies for movement and support, as well as for metabolic processes and reproduction.

We humans have traits that enable us to live on land. Our lungs are designed for removing oxygen from atmospheric air, our skin prevents our vital organs from drying out, and we have complex organs that regulate temperature, retain water for biological functioning, and remove waste products from our body. Our skeletons give us the support to stand upright in low-density air. Early prehistoric marine life met these challenges by evolving to occupy ecological niches on land with, among other adaptations, the move from spores to seeds for plants, and the development of the amniotic egg for animals.

ABOVE LEFT: The fossilized shell of the Late Cretaceous sea snail *Pterocerella* sp. (YPM 9046).

ABOVE RIGHT: A preserved modern specimen of *Octopus* sp.

CENTER LEFT: Several specimens of the Ordovician crinoid *Reteocrinus onealli* (YPM 7495) can be seen in this fossil.

CENTER RIGHT: The skeletal structure of the modern coral *Allopora* (YPM 27318).

BELOW LEFT: The shell of the Quaternary brachiopod *Terebratula* sp. (YPM 9073).

BELOW RIGHT: The shell of the chambered nautilus—*Nautilus pompilius* (YPM 22690), a cephalopod, here cut in half to show the interior segmentation noted for its regular proportions—is used by the animal to adjust its buoyancy.

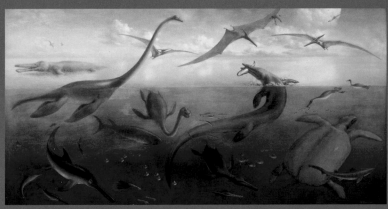

Rudolph Zallinger's painting of a generalized Cretaceous seascape depicts prehistoric fish, reptiles, birds, and other animals.

A Riot of Life: The Carboniferous Period

The dense forest that fills most of the right-hand side of the mural represents the explosion of land plant diversity that occurred during the Carboniferous Period. By this time, plants had radiated to all but the most extreme of terrestrial environments, but nowhere were they more successful than in the vast equatorial lowlands that stretched from what is now eastern North America, across Europe, and into Asia. It was during the Carboniferous Period that the most abundant of the earth's future coal supplies accumulated.

The towering *Lepidodendron* dominated many of the wettest parts of this swampy forest. It is depicted in the center of the right-hand section of the mural. *Lepidodendron* was identified by the conspicuous, diamond-shaped leaf scars on its trunk and branches. This bizarre giant reached heights of over 140 feet (45 meters).

Closely related to *Lepidodendron* and growing on similarly wet sites was *Sigillaria*, also named for its pattern of leaf scars. This line of trees became extinct by the end of the Permian Period, leaving only a few living relatives like the small herbaceous plants sometimes called ground pines.

The abundance of fern leaf impressions in the Carboniferous fossil record explains why this time period is often called the Age of Ferns. *Calamites*, a relative of the modern plants with jointed stems called horsetails, was another important component of the swamp forest. It was particularly abundant along stream levees where it formed luxuriant stands.

Amid this assemblage of archaic plants, the lineage of limbed vertebrates, or Tetrapoda, continued to change and diversify. The earliest tetrapods were carnivores and therefore did not consume plants directly. Instead, they fed on insects, such as the wide-winged *Meganeuropsis* (poised above the water toward the right of the mural), and other animals that did process plant tissue.

Forests of the Carboniferous Period, or "Coal Age," are responsible for the vast coal deposits in the eastern and midwestern United States, a tremendous accumulation of compressed plant materials. At that time, Europe and North America were located along the equator, and the tropical climate allowed the growth of lush lowland forests over much of the area.

Lepidodendron (LEP-i-doe-DEN-dron) was a branched tree with needle-like leaves on the **apices** of diamond-shaped cushions. These diamond-shaped bark patterns are very conspicuous in fossil remains of trunks and branches. Coal miners often call them "snake skins" or "fish scales." Spores were produced in specialized structures aggregated into cones on the tips of branches. Although depicted in both the Carboniferous and Permian sections of the mural, there is no fossil evidence of *Lepidodendron* in the Permian Period.

This fossilized bark of *Lepidodendron* sp. (YPM 53179) from the Peabody's paleobotany collection clearly shows its diamond-shaped patterns.

Sigillaria (si-jil-AIR-ee-a) was less conspicuously branched, or sometimes not branched at all, with a crown of long, grasslike leaves. Its bark was marked by prominent vertical ribs, and leaf scars are evident on these raised ribs.

Meganeuropsis (meg-a-new-ROP-sis) was a giant relative of the modern dragonfly. This insect had a wingspread of nearly 30 inches (76 centimeters). It is shown here life-size along with the 5-foot (1.5-meter) millipede-like arthropod *Arthropleura*.

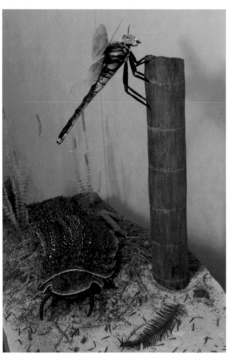

The large, salamander-like ***Eryops*** (AIR-ee-ops) was a **temnospondyl tetrapodomorph** that was better adapted to terrestrial life than the embolomeres, *Eogyrinus* and *Diplovertebron*. *Eryops* is shown in the Carboniferous Period, but this animal was most common during the Permian Period. *Eryops* grew to about six feet (two meters) in length and probably weighed as much as an average-sized man (see the skeletal reconstruction below). The name *Eryops* refers to its long, flat face.

Arising in the Carboniferous Period, the **basal** tetrapods depicted in this section of the mural represent early species of the two great groups surviving today: Amphibia and Amniota. The long, squat, broad-headed animals—*Eogyrinus* in the stream, and *Diplovertebron* and *Eryops* sprawled on the far shore—probably retained an amphibious lifestyle; that is to say, they still reproduced in the water and spent much of their time there, but were also able to crawl over nearby land.

Although they all retained an amphibious lifestyle, only *Eryops* is related, albeit distantly, to the true amphibians of today, the frogs, salamanders, and caecilians. *Eogyrinus* and *Diplovertebron* are actually very distant cousins of the fully terrestrial and land egg-laying **amniotes** of today, the mammals, turtles, lizards, crocodilians, and birds.

The plants shown on the right of the mural in the area devoted to the Carboniferous Period all reproduced by **spores**. This is only an incomplete adaptation to the land environment, because fertilization of the egg cells that the plants produce can take place only in a wet environment, the necessary moisture usually supplied by rain. Late in the Devonian Period a new means of plant reproduction appeared—the **seed**—that internalized fertilization by retaining the female spore within a protective coat on the parent plant. The evolutionary development of the seed, like the appearance of the amniotic egg among vertebrate animals, represented another advance separating land plants from their aquatic ancestors.

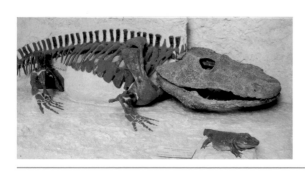

The seed plants had the advantage over plants that used the more primitive mode of reproduction by spores in that they were now free to radiate into drier upland regions of the world (which are not represented in the mural because we have many fewer fossils from such environments). The lone tree on the approximate boundary of the Carboniferous and Permian scenes, *Cordaites*, is a moderately early representative of the conifer lineage, one major line of the **gymnosperms**, or nonflowering seed plants, which occupied drier and more marginal habitats in the lowland coal swamps of both the Carboniferous and Permian Periods.

Eogyrinus (ee-o-JEYE-rine-us), pictured swimming in the stream, and *Diplovertebron* (diplo-VERT-e-bron), shown basking on the far bank of the stream, are closely related **embolomere** tetrapods. Both were aquatic predators with muscular tails for swimming. *Diplovertebron* likely used its limbs only when traversing muddy shallows and the occasional stretch of dry land. *Eogyrinus* had reduced limbs that may not have served any function in terrestrial locomotion.

Relatives of the horsetails, such as the **genus *Calamites*** (ka-la-MY-tees), also attained treelike proportions. None of these plants in the mural actually shows the true size of the larger forms. *Calamites* had jointed stems, with leaves borne in conspicuous whorls.

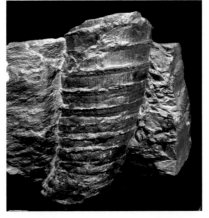

Fossilized trunk of *Calamites* (YPM 49147), from the Peabody paleobotany collection.

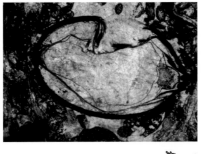

A magnified lengthwise cut through a 320-million-year-old fossil seed of *Lagenostoma* (YPM 2705) from the Carboniferous Period. The seed has partially collapsed and the tissues of the **gametophyte** have been pushed toward the center.

Cordaites (kor-DYE-tees), related to modern conifers, had large trunks with dense wood, and broad, strap-shaped leaves. Pollen and seeds were borne on its slender **axes**. This Carboniferous tree is misplaced in the Permian section of the mural.

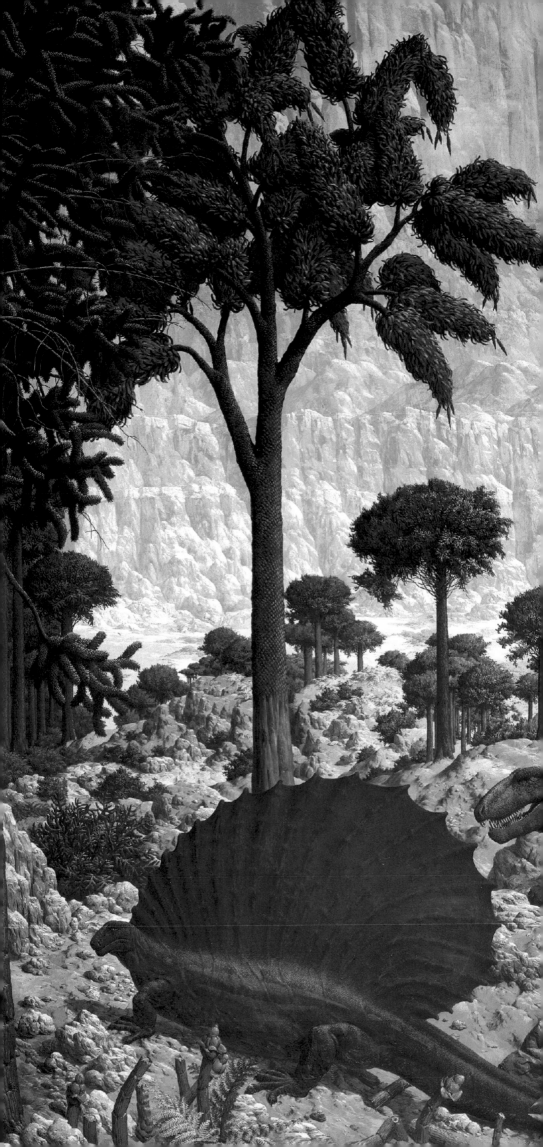

Remaking the World: The Permian Period

The Permian Period, 290 to 248 million years ago, was one of the greatest episodes of mountain building in earth's history. All of the continents collided to form a single, huge land mass called Pangaea. The climatic effects of this collision were profound, producing vast dry areas in the continental interiors and perhaps the most pronounced temperature extremes in the history of life on earth. Although most lineages of spore-bearing plants that had dominated earth's vegetation in the Devonian Period managed to survive into the Permian, the increasingly arid and seasonal climatic regime caused most major lines of coal-swamp trees to go extinct before the end of the Permian Period.

The last survivors of these lineages lingered on in the dwindling swamps on the moist east coast of Pangaea, in what is now modern China. The plants that were to dominate the drastically changed world depicted in the central portion of *The Age of Reptiles* would be the ferns and seed plants, including close relatives of our modern conifers, such as the **Araucarioxylon** that stands on the border of the Permian and the Triassic sections of the mural.

During the Permian Period, upland regions became home to vertebrates that had a more completely terrestrial lifestyle. This group of vertebrates, the Amniota, is today represented by mammals and reptiles. Although amniotes first appeared in the Carboniferous Period, the Permian Period saw a great diversification in forms. As the distribution of amniotes spread into the continental interior, the lowland bayou, swamp environments of the Permian Period continued to be inhabited by amphibious tetrapods. **Limnoscelis**, seen comfortably basking on the fallen tree in the Carboniferous section of the mural, was a tetrapod either within or closely related to the Amniota. The occupant of the small island in the foreground, **Seymouria**, was a tetrapod more distantly related to amniotes than *Limnoscelis*.

Amniota is composed of two separate lineages of animals. These are the Diapsida, today represented by lizards (including snakes), crocodiles, and birds, and the Synapsida, today represented by mammals. Incorrectly referred to as "mammal-like reptiles," the synapsids of the Permian Period are actually not reptiles at all. Although they look rep-

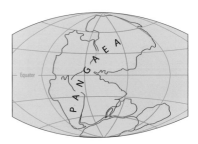

Although it began as a rather quiet time characterized by lowland swamps and fern jungles, the Permian Period was a time of major geological events, including **glaciations** and **orogenies**. The collision of North America and Africa in the Permian Period formed the Appalachian Mountains of the eastern United States. This particular event is portrayed symbolically in the mural by the prominent cliffs and mountains in the background on the left of the Permian section. (Courtesy of the U.S. Geological Survey.)

 The extinct conifer **Araucarioxylon** is the majestic tree that towers over the beginning of the Triassic section of the mural. Some of the tall forest giants in the background represent extinct conifers or early representatives of modern conifers such as *Araucaria*, which entered the picture as the Mesozoic wore on. Some of these conifers could have belonged to such related species as *Walchia*, *Lebachia*, or *Ernestiodendron*.

Seymouria (see-MORE-ee-a) reached an adult length of about two feet (less than a meter). It was named for Seymour, Texas, a town close to the site of its discovery. *Seymouria* was a member of Tetrapodomorpha, the lineage of limbed vertebrates leading to the living group Tetrapoda. *Seymouria* had several adaptations for terrestrial life, so it was probably less amphibious than tetrapodomorphs like *Eogyrinus* and *Diplovertebron*.

 The small, lizard-like reptile depicted between *Dimetrodon* and *Edaphosaurus* is **Araeoscelis** (air-ee-OS-i-lis). Though not a lizard, *Araeoscelis* was a primitive member of the group Diapsida, a lineage of reptiles that is represented today by lizards, along with birds and crocodiles.

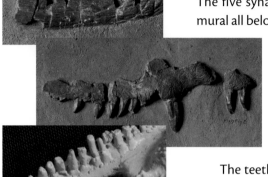

A comparison of the teeth of *Ophiacodon* (top, YPM 808), *Sphenacodon* (middle, YPM 806) and *Edaphosaurus* (bottom, cast, YPM 14686A).

tilian at first glance, these animals are actually more closely related to you than they are to any reptile! The five synapsids depicted in this section of the mural all belong to the group Eupelycosauria. These are **Varanosaurus** (eyeing *Seymouria* on the island), **Ophiacodon** (resting on the bank beyond), **Sphenacodon** (on the bluff overlooking the bayou), and **Dimetrodon** and **Edaphosaurus** (the two large animals with great "sails" on their backs).

The teeth of these **eupelycosaurs** reveal some variation in food preference, and therefore lifestyle, within the group. For example, the uniformly small, sharp-pointed teeth of *Varanosaurus* and *Ophiacodon* suggest a fish diet and therefore a lowland existence. The larger, dagger-like teeth of *Sphenacodon* and *Dimetrodon* point to a fleshy diet and a more terrestrial mode of life. *Edaphosaurus* sported blunt, peglike teeth and probably dined on plants.

Quite abundant and diverse during the Permian, several types of eupelycosaurs are portrayed in the Permian section of the mural. **Varanosaurus** (var-AN-o-SAWR-us), the brownish animal near the stream in the foreground, was a primitive eupelycosaur with an amphibious lifestyle. *Varanosaurus* grew to about three feet (one meter) in length and was most likely a **piscivore**, or fish eater.

Closely related to *Varanosaurus*, but more **derived**, was the larger eupelycosaur **Ophiacodon** (o-fee-AK-o-don), which could have reached lengths of over 10 feet (3 meters). Jaws armed with many needlelike teeth, a salamander-like body and a long, muscular tail indicate a lifestyle of active aquatic predation.

With a length of 8 to 10 feet (2 to 3 meters), **Sphenacodon** (sfeen-AK-o-don) was a large eupelycosaur closely related to *Dimetrodon*. Although the **neural spines** of *Sphenacodon's* backbone were nowhere near as long as *Dimetrodon's*, they were longer than those of other eupelycosaurs without sails.

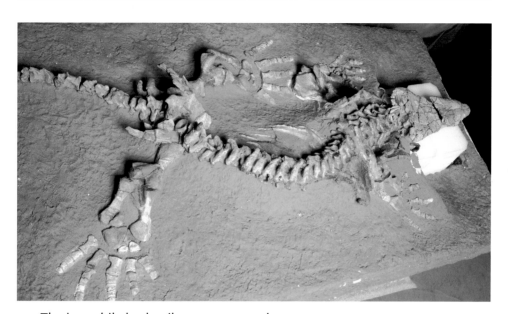

The immobile back sails on some eupelyco-saurs have prompted much speculation. What could these giant sails possibly have been used for? The size of the sail varied disproportionately with the bulk of the animal. In other words, as eupelyco-saur body sizes increased, the surface area of the sail increased at an even greater rate. This has led to the idea that these impressive structures were an early experiment in the maintenance of a constant body temperature. Perhaps these animals turned the sail to face the sun to absorb solar radiation and increase body temperature, and turned it away from the sun to radiate body heat and decrease body temperature. Another possibility is that eu-pelycosaurs used their sails as a way of attracting the attention of a mate, in much the same way that a peacock uses its enormous, colorful tail feathers.

Almost unnoticed in the mural because of its relatively small size is the reptile **Araeoscelis**. There were no lizards during the Permian, but *Araeoscelis* probably lived like a lizard, scurrying after insects and grubs in the underbrush. *Araeoscelis* did not belong to Synapsida, but rather to Diapsida.

Limnoscelis (lim-NO-sell-is) was 15 feet (5 meters) long. It was an early member or close relative of Amniota, an incredibly diverse group of tetrapods that is today represented by mammals and reptiles. Above, the only complete *Limnoscelis* skeleton (YPM 811) ever discovered, housed in the Peabody collections.

Dimetrodon (di-MEET-roe-don) was a eupelyco-saur that reached a length of 10 feet (3 meters) and probably weighed more than 220 pounds (100 kilograms). This animal had an extremely high sail formed of elongated neural spines on its vertebrae. *Dimetrodon* was the larg-est North American land carnivore dur-ing the Permian Period.

Edaphosaurus (ee-DAF-o-SAWR-us) had a great sail along its back, but unlike the sail of *Dimetrodon*, that of *Edaphosaurus* had short cross bars that projected out from either side of the long neural spines of the back. These cross bars increased the turbulence of air flow-ing across the sail, thus increasing the structure's effectiveness at dissipating body heat. Another way that *Edapho-saurus* differed from *Dimetrodon* was in its diet. *Dimetrodon* was an active carnivorous predator; *Edaphosaurus* was one of the earliest terrestrial her-bivores.

An unusual cycad, **Bju-via** (ZHEW-vi-a), with a squat growth habit and broad, undivided leaves, is conspicuous in the Triassic scene. Its seed-bearing organs were borne in a compact crown at its **apex**.

Wielandiella (we-land-i-ELL-a), named for Yale paleobotanist George Wieland, was a graceful, branched cycadeoid with narrow, toothed leaves. Its seeds developed in compact clusters.

George R. Wieland came to Yale intending to study vertebrate paleontology, but while collecting fossils for O. C. Marsh in South Dakota during the summer of 1898 he met the paleobotanist Lester Ward. Ward had made a collection of cycadeoid trunks in the Black Hills of South Dakota in 1893, and it was through Ward's encouragement and Marsh's collecting that Wieland's scientific interest in these fossil trunks flourished. It is principally through Wieland's efforts that Yale accumulated a collection of about 1,000 specimens, probably the world's largest collection of cycadeoids.

Other cycad-like plants of the Triassic included **Macrotaeniopteris** (mack-ro-teen-i-OP-ter-is), which has individual leaves.

Well before the end of the Permian Period, geological events were setting the stage for the future of animal and plant life in the Mesozoic Era. True conifers made their appearance in the drier, more upland settings of the late Carboniferous Period and assumed a steadily more important role as humid, equable climates deteriorated. Some modern-looking conifers were at home in the landscape long before the extinction of the dinosaurs.

Yet another group of gymnosperms, the cycads with their crowns of palmlike leaves, appeared in the late Carboniferous Period and became an important component of Mesozoic vegetation. **Bju-via** is conspicuous among this group. Coexisting with the true cycads was another superficially similar group of plants, the Cycadeoids (or Bennettites), such as **Wielandiella** and **Macrotaeniopteris**.

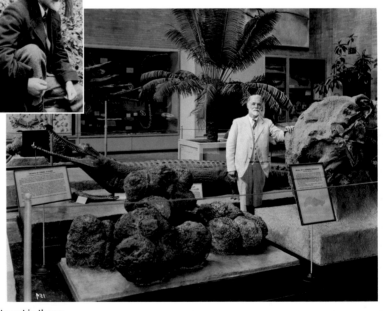

George Wieland in the Peabody's Great Hall, November 8, 1931.

THE PERMIAN EXTINCTION

Imagine a world nearly devoid of life. At the end of the Permian Period, 250 million years ago, the earth experienced the most devastating extinction of all time, much greater even than the extinction that decimated the non-avian dinosaurs. Land animals and plants suffered major losses and in several million years over 90% of all marine life went extinct. The survivors were given an unparalleled opportunity to flourish.

There were many probable causes of the Permian extinction, all linked by complicated mechanisms. That nearly all marine life went extinct and terrestrial organisms suffered major losses indicates a link between atmospheric and oceanic changes. Plate tectonics, the movement of the large crustal plates that make up the continents and ocean floor, could also have played a significant role.

At the end of the Permian Period, the continental plates were arranged into one enormous supercontinent, called Pangaea, and surrounded by the Panthalassa Ocean. In such an arrangement the available shallow oceanic environment was seriously depleted. The change in plate configurations could have affected oceanic and atmospheric circulation, an additional blow to marine and terrestrial life. Tectonic movement is also linked to greenhouse gas emissions both at ocean spreading ridges and from volcanoes. Scientists continue to find evidence for the chain of related events, such as a breakdown in oceanic circulation and widespread oxygen depletion, that caused the greatest mass extinction of all time.

These two specimens of *Hercosia* sp. (YPM 50237), from the Permian of West Texas, USA, have unusual cone shapes and spines adapted for growing in clusters in a reef. Reefs composed of brachiopods, sponges, and bryozoa were common across equatorial regions during the Permian.

Trilobites were common from the Cambrian through the end of the Paleozoic, when they became extinct at the end of the Permian Period. This specimen of *Triarthrus eatoni* (YPM 210) from the Late Ordovician locality in Oneida County, New York, USA, known as "Beecher's Trilobite Bed" has been fossilized by the mineral pyrite.

Preservation of insects is rare in the fossil record. This dragonfly relative, *Dunbaria fasciipennis* (YPM 1002), is from the Permian of Kansas.

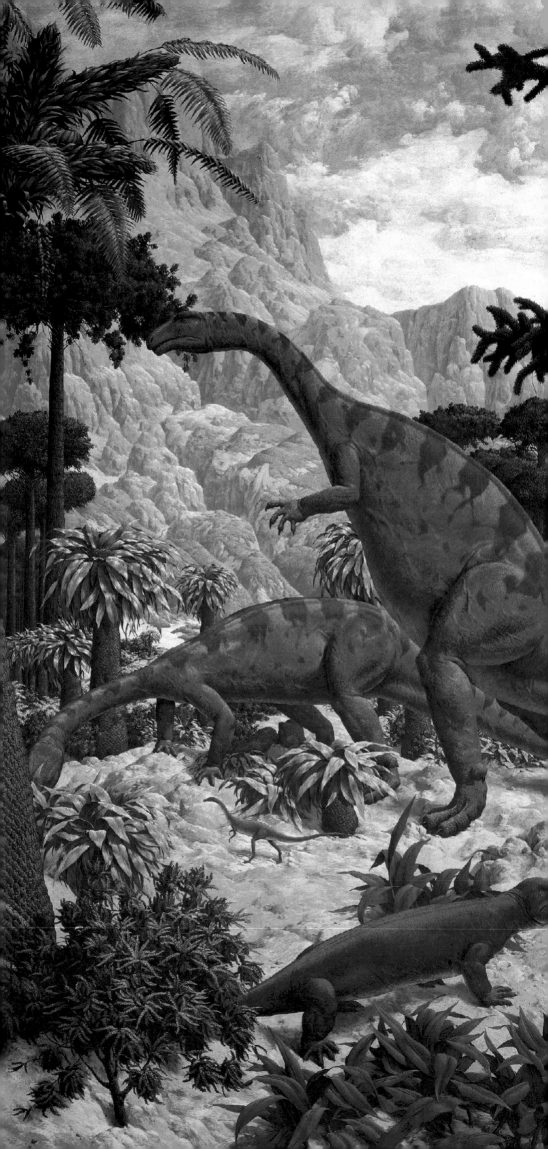

Dawn of the Age of Dinosaurs: The Triassic Period

The greatest mass extinction in earth's history brought an end to the Permian Period. The succeeding Triassic Period was characterized by a very different fauna. Although many of the Permian eupelycosaurs went extinct, a more derived group of eupelycosaurs, the Therapsida, increased in abundance and diversity in the Triassic Period.

Only one kind of **therapsid**, the imposing carnivore *Cynognathus*, is portrayed in the mural. Unlike the more primitive eupelycosaurs, *Cynognathus* and other therapsids were able to assume a more upright posture. In fact, with a multitude of new adaptations to improve terrestrial mobility and **predation**, the anatomy of **cynodont** therapsids like *Cynognathus* was much closer to the mammal condition than was that of the Permian eupelycosaurs.

Running toward *Cynognathus* is **Saltoposuchus**, a small, long-tailed, bipedal animal. *Saltoposuchus* was among the first animals to achieve a bipedal stance and gait, the ability to stand and move on two legs. Because **bipedalism** was a feature perfected by dinosaurs, it was long thought that **Saltoposuchus** was a close relative of Dinosauria. New studies, however, indicate that this animal was probably more closely related to crocodiles than to dinosaurs.

As the Triassic unfolded, large therapsids went into decline, giving a new group, the Archosauria, the opportunity to radiate. Archosauria is the group of reptiles that is today represented by birds and crocodiles. The most diverse group of **archosaurs**, the dinosaurs, range in size from the smallest hummingbird up to the extinct giants that could have weighed more than 100 tons. First appearing in the Triassic Period, dinosaurs have thrived all over the world for well over 200 million years.

The term "dinosaur" is known to virtually everyone, but it is often used improperly. Although true dinosaurs have an incredible diversity of body types and lifestyles, all share a single common ancestor. The term "Dinosauria" ("fearfully great lizard") specifically refers to any animal descended from the **most recent common ancestor** of the two dinosaur lineages, the Saurischia ("reptile hip") and the Ornithischia ("bird hip"). Saurischia includes the bipedal, carnivorous **theropods** and the long-necked, giant sauropods. Ornithischia is an en-

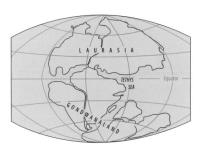

As the supercontinent of Pangaea began to fragment in the Triassic Period, new ocean basins formed and the North American continent was subjected to extensive erosion. Some regions were quite arid, while others alternated between wet and dry seasons. Locally, volcanoes spewed out great lava flows. The climate was quite warm, like the tropics of today, and forests and lush vegetation grew in many places. It was in this setting that the first **dinosaurs** appeared. (Courtesy of the U.S. Geological Survey.)

Cynodonts evolved from among the many kinds of therapsids around the world during the Triassic Period and survive today as living mammals. Although mammalian cynodonts first appeared in the Jurassic Period, it was not until the decline of large dinosaurs at the end of the Mesozoic Era that mammals experienced a major radiation. The one cynodont therapsid in the mural, **Cynognathus** (sine-o-NAY-thus), is the quadrupedal animal depicted in the foreground of the Triassic section. *Cynognathus* was an active predator, with sharp teeth, long fangs, and a more upright gait than primitive eupelycosaurs.

The small blue-gray, bipedal animal in the foreground at the right side of the Triassic section of the mural is **Saltoposuchus** (SAL-toe-po-SOOK-us). Its name, which means "leaping crocodile," alludes to the conspicuous disparity between the lengths of its hind limbs and forelimbs.

Cladistics is a method of modeling the evolutionary history of organisms. A powerful modern tool for studying and understanding evolution, cladistics attempts to do for the entire history of life what genealogy does for the history of human families: to disentangle the genetic relationships among living things. But while genealogy focuses on detailed lineages of ancestry and descent, cladistics focuses on identifying the common ancestry of related groups of organisms.

This is a simplified **cladogram** showing the relationships among the major groups of dinosaurs. Each branch is named for a particular group; each point where two branches meet is the position of the most recent common ancestor of the two groups represented by those branches. The point between the Saurischia and Ornithischia branches is labeled "Dinosauria" on the cladogram because it represents the most recent common ancestor of all dinosaurs.

tirely extinct group of herbivorous dinosaurs that included **quadrupedal** animals such as *Stegosaurus*, *Ankylosaurus*, and *Triceratops*, as well as bipedal **ornithopods** such as *Iguanodon* and *Edaphosaurus*. With this definition, the group Dinosauria excludes animals like pterosaurs, ichthyosaurs, plesiosaurs, and *Dimetrodon*.

Prominent among the dinosaurs of the Late Triassic Period were the prosauropods. In the mural, a pair of prosauropods called **Plateosaurus** dominates the scene beyond *Cynognathus*. Members of the group Prosauropoda have been discovered in Triassic rocks on nearly every continent, and consequently are thought to have been well adapted to a variety of environmental conditions. One explanation for their success could be their upright posture and gait, which would enable them to breathe while running. Notice that their limbs are positioned nearly vertically rather than sprawled to the sides of their bodies (which limits the ability to breathe while running), as was the case with the primitive eupelycosaurs of the Permian Period. Moreover, the prosauropods were likely capable of limited bipedal locomotion. This would have improved their ability to evade potential predators, a great advantage and possible explanation for their ability to thrive in such widespread areas. Prosauropods were perhaps the first dinosaurian **browsers**, which could have been promoted by a bipedal stance and long neck that enabled them to reach foliage on high branches.

In the mural, almost lost among the shrubs at the feet of *Plateosaurus*, is a small, bipedal, long-tailed animal with the curious name **Podokesaurus**. The status of *Podokesaurus* has long been in question because there is little to distinguish it from a previously discovered and named contemporary, *Coelophysis*. The only known fossil of *Podokesaurus*, a partial skeleton, was found near the campus of Mount Holyoke College in Massachusetts. Unfortunately, that specimen was destroyed in a fire some years later, so the controversy of names has been particularly difficult to settle. Although similar in appearance, *Coelophysis* and *Podokesaurus* do not share any derived features. As a result, it is

impossible to unite the two species and the name *Podokesaurus* continues to refer to that single, lost specimen. *Podokesaurus* and *Coelophysis* are early members of the group Theropoda, a group of bipedal, carnivorous saurischians.

A long line of theropods followed, including *Allosaurus*, *Ceratosaurus*, *Tyrannosaurus*, and *Deinonychus* of North America; *Megalosaurus* and *Poekilopleuron* of Europe; and the virtually identical Asiatic twin of *Tyrannosaurus* called *Tarbosaurus*. Theropods are the only dinosaurs to survive the mass extinction at the end of the Cretaceous Period and one group of theropods, the birds, is the only group of dinosaurs still alive today.

The two large, bipedal animals behind *Saltoposuchus* are the Late Triassic prosauropod dinosaur **Plateosaurus** (PLATE-ee-o-SAWR-us). Relatively large herbivores, prosauropods are early representatives of the dinosaur group Saurischia.

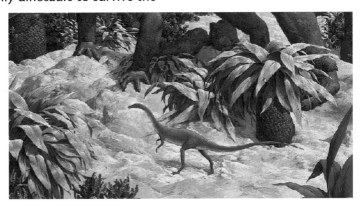

The small, two-legged animal beneath *Plateosaurus* is **Podokesaurus** (po-DOE-key-SAWR-us), a close relative of *Coelophysis* (SEAL-o-FIE-sis) and early member of the carnivorous, bipedal saurischian dinosaur group Theropoda. It is one of the few dinosaur skeletons found in New England.

RAINBOWS IN STONE

Araucarian trees lived more than 225 million years ago, during the time of the dinosaurs, once part of a great forest that extended from Texas into Utah. Today, these trees survive only in the temperate to subtropical parts of the southern hemisphere, just crossing the equator into the Philippines. They seem to have been eliminated from more northern areas by the same catastrophe that caused the extinctions at the end of the Cretaceous Period.

Judging from the size of their trunks and the stature of their descendants, araucarian trees grew upwards of 150 to 200 feet (45 to 60 meters) in height, with trunks 4 to 5 feet (about 1.5 meters) in diameter. Some paleobotanists believe that the characteristic umbrella shape of many modern araucarians has been retained from the time when this shape served to protect their foliage from grazing by the gigantic sauropod dinosaurs, like *Apatosaurus*.

After these trees died and were toppled, they were transported by streams into swampy lowlands. As they tumbled along, branches, bark and small roots broke off or were worn away. Over time the logs were buried in silt, mudstone, or volcanic ash. This blanket of sediment cut off oxygen to the logs, slowing decay. At the same time, groundwater seeped through the logs, encasing the original cell structure of the wood in silica that hardened into stone.

Petrified wood is among the most common of fossilized plant remains, and can be found worldwide. Although silica, in the form of quartz or even opal, is among the most abundant of the about 40 minerals identified in petrified wood, these can also include semiprecious minerals such as jasper and chalcedony. During the process of **petrifaction** mineral impurities mix with the silica to produce highly prized "rainbow wood" with a brilliant array of colors that come from manganese oxides (blues, blacks, purples), gypsum (white), and the iron oxides limonite (yellow) and hematite (red, rust).

This gemlike polished cross section (YPM 45161) and petrified trunk (YPM 45162) of *Araucarioxylon arizonicum* from the Late Triassic Period of Arizona, USA, are examples of highly prized "rainbow wood."

An extensive forest of araucarian trees is found today growing in New Caledonia. (Photograph courtesy of Gregory J. Watkins-Colwell.)

THE TREE OF LIFE

All living things, from the smallest microorganism to the largest vertebrate or redwood tree, are genetically related. This genetic relatedness is expressed as an immense evolutionary "Tree of Life," or **phylogeny**, which provides the framework for our modern understanding of biology. Not only does the tree display the full diversity of life, it also reveals the history of the similarities and differences among the lineages of organisms as these have changed through time.

Scientists make careful use of the molecular and morphological characteristics of living and fossil organisms to infer how they are related to one another. Over the last few decades, with important theoretical developments and the availability of new sources of data and powerful computational tools, we have learned a great deal about phylogeny. However, our knowledge is still very far from complete, and many more surprises are in store, even about the relationships of the major branches of the tree of life. With some 1.75 million species discovered and described to date, and probably tens of millions yet to be found, the task of reconstructing the entire tree of life presents one of the largest and most complex scientific problems facing biologists today.

Knowledge of the tree of life has become critically important in areas as diverse as human health, natural resource management, and agriculture. For example, work on the relationships among different groups of poisonous snakes in Australia has shown that certain species that look very different, such as the king brown snake (*Pseudechis australis*) and the red-bellied black snake (*Pseudechis porphyriachus*), are actually closely related. This led to the life-saving realization that the same antivenin could be used to treat bites from both species.

Understanding how organisms are related to one another is also a powerful tool for identifying disease organisms, tracing the history of infections, and predicting outbreaks. Phylogenetic analysis enabled health workers to quickly identify the West Nile virus when it emerged in New York in 1999, providing key information about the basic biology and the geographic origin of the virus that was needed for diagnosis and predicting its spread. Identifying potential invasive species, which cost the United States billions of dollars annually, is of crucial economic and ecological importance. The finding that a green alga found at several locations along the California coast is closely related to a highly invasive strain that has caused extensive ecological damage in the Mediterranean pointed to the need for an immediate eradication program to protect the coastal ecosystem. Many new phylogenetic insights are on the horizon and we anticipate great advances in this budding area of biology in the years to come.

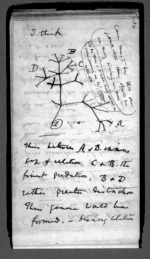

This first known sketch of an evolutionary tree by Charles Darwin illustrates the relationships among groups of organisms. (By permission of the Syndics of Cambridge University Library.)

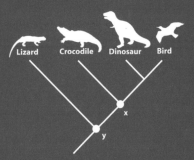

This example of a basic evolutionary tree can be used to describe the relationships among the species shown. For example, a crocodile is more closely related to a bird than to a lizard, because the most recent common ancestor of both is at the node marked "X." This is a closer relationship than that between the crocodile and the lizard, because the most recent common ancestor at node "Y" is "deeper," or farther down, in the tree.

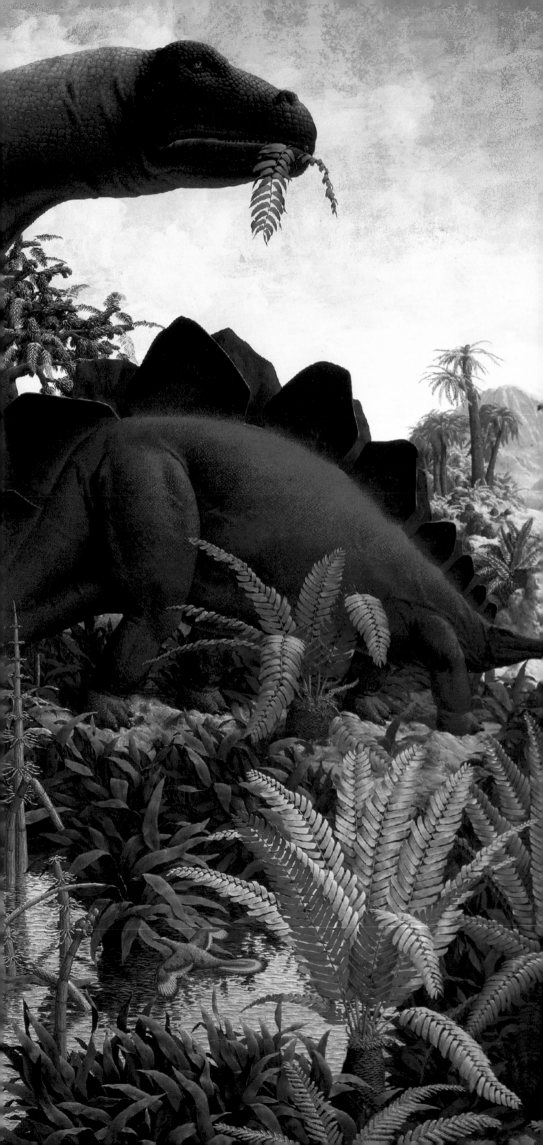

High Noon of the Dinosaurs: The Jurassic Period

Although some changes are apparent in the vegetation of the Jurassic Period, especially the reduced importance of seed ferns in areas of the Southern Hemisphere (not shown in the mural), for the most part the period represents a continuation of lines already well established in Triassic times. Some cycadeoids, such as **Williamsonia**, with its crown of divided, cycad-like leaves, had attained the stature of moderately tall trees.

Cycadeoidea had a highly characteristic squat, barrel-shaped trunk that also bore a crown of divided cycad-like leaves. The deep scars left by its fronds have caused the fossilized trunks to be mistaken for petrified old-fashioned straw beehives. It is now believed that the flower-like structures on the trunks of the cycadeoids in the mural did not open up like flowers. Instead, they seem to have been pollinated by beetles that bored their way into these flowerlike structures to feed on the rich store of pollen there. Like plants today, the cycadeoids must have received more benefit from having pollen transported from one plant to another, outweighing the loss of the pollen that was eaten. The existence of this phenomenon in the Jurassic points the way to the establishment of the **pollination** strategies of the primitive flowering plants during the succeeding Cretaceous Period.

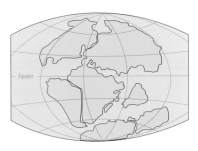

During the Jurassic Period, the continental interior of Pangaea was hot and dry. Dinosaurian evolution continued and a variety of dinosaurian types appeared, from the enormous sauropods and carnivorous theropods of the Saurischia to the still bipedal ornithopods and plated stegosaurs of the Ornithischia. The mammals first appeared in the Jurassic. (Courtesy of the U.S. Geological Survey.)

The large treelike **Williamsonia** (wil-yum-SONE-ee-a) had elongated compound leaves. Compact conelike structures among the leaves held pollen and seed-bearing organs.

Another cycadeoid that first appeared in the Jurassic, and extended into the Cretaceous, was *Cycadeoidea* (sy-kad-ee-OYD-i-a), also called *Bennettites* (be-ne-TIE-tees). These were squat plants with barrel-shaped trunks.

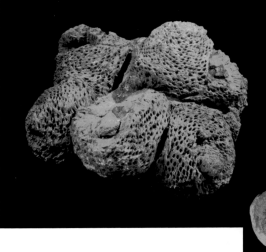

Above, *Cycadeoidea marshiana* (YPM 151323), a branching cycadeoid from the lower Cretaceous of South Dakota, USA. Below, the fossilized foliage of the Jurassic cycadeoid *Sphenozamites* sp. (YPM 28360).

Araucarites (a-ra-ka-RYE-tees), similar to modern conifers, was abundant. Today the araucarian family is restricted to the Southern Hemisphere, just crossing the equator in the Philippines, but during the Mesozoic Era these trees were common in temperate and subtropical parts of both hemispheres.

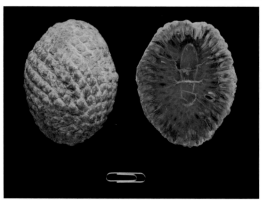

Fossilized cones of *Araucaria mirabilis* (YPM 53181a,b) from the Jurassic of Cerro Cuadrado, Patagonia, Argentina.

The Jurassic **Matonidium** (ma-tone-ID-i-um) has much in common with present-day relatives of the fern lineage. Several modern fern lineages had early representatives in the Jurassic Period.

Neocalamites (NEE-o-ka-la-MY-tees), one of the Mesozoic relatives of modern horsetails, resembled the Paleozoic *Calamites*, but was generally smaller.

Araucarian trees such as **Araucarites**, as well as other plants increasingly similar to modern conifers, grew in abundance in the Jurassic landscape. Among the ferns shown in the mural, **Matonidium**, with its low stems and erect, palmately divided leaves, was a highly characteristic part of the ground cover. Thus, although the vegetation of the Jurassic would still have looked strange to modern eyes, the conifers and ferns would have lent a familiar cast to the landscape.

One plant that has left no direct successors is **Neocalamites**, a shrubby descendant of the late Paleozoic *Calamites*. Modern relatives of this plant, the horsetails, are known to have existed as far back as the Carboniferous.

In striking contrast to the slowly changing plant record of the Triassic Period, the Jurassic Period saw an explosion in dinosaur diversity with the introduction of forms quite unlike those of the Triassic Period. Many of the Jurassic dinosaurs are very well known; indeed, some of them have become household names.

Allosaurus was a large predator that likely fed on any animal that crossed its path. Even the large size of Jurassic sauropods may not have made them safe. Fossil bones of *Apatosaurus* occasionally preserve the unmistakable tooth marks of large carnivorous dinosaurs like *Allosaurus* and *Ceratosaurus*. As a theropod, *Allosaurus* was an obligatory biped that could neither stand nor walk on all fours. Theropods represent one of very few examples of **obligatory bipedalism** in the history of animal life; humans represent another. Bipedalism offers certain advantages to predatory animals. By standing up on its hind limbs, an animal expands its field of vision and range of smell. It also frees up the forelimbs to perform other functions, like seizing fleeing prey.

In the mural, the commanding *Allosaurus* overshadows the crow-sized theropod **Compsognathus**. This miniature predator is one of the smallest known extinct dinosaurs. Recent discoveries suggest that *Compsognathus* was covered with short, filamentous structures, the precursor to true feathers. Although these **protofeathers** predate the

origin of flight, they likely served other important functions, such as body insulation or in the recognition and selection of mates.

Theropods were not the only bipedal dinosaurs that roamed the Jurassic landscape. Members of the Ornithischia were also able to stand and walk on their hind limbs, but were not obligatory bipeds like the theropods. These animals spent much of their time on all fours but were also able to use a bipedal stance and gait when necessary.

Camptosaurus was an early example of a very successful group of ornithischian dinosaurs called Ornithopoda. The name Ornithopoda means "bird foot" and refers to the three-toed feet of the members of this group. It is important to remember that names like Ornithopoda and Ornithischia ("bird hip") simply refer to recognizable features of these groups, and do not suggest actual relationships. Birds are neither ornithopods nor ornithischians. Instead, birds fit into the groups Theropoda ("beast foot") and Saurischia ("lizard hip")!

Ornithopods first appeared in the Jurassic Period and lasted until the end of the Cretaceous Period. The ornithopods may owe part of their successful reign to their bipedalism. As with the theropods, an upright stance would have provided a better view of their surroundings, thus allowing early detection of any threatening predators. Another possible benefit of bipedality is an increased browsing range, the ability to feed higher up in the brush and tree branches. This likely gave them a

Allosaurus (AL-o-SAWR-us) was among the largest and most abundant of the large Jurassic theropods. A heavily built biped, *Allosaurus* was likely well adapted for stalking and overpowering prey, but not for chasing it down. Once thought to be smaller than *Tyrannosaurus rex*, recent discoveries show that *Allosaurus* was almost 20 feet tall (6 meters), 46 feet (14 meters) long, and could have weighed more than eight or nine tons (seven to eight metric tons).

Compsognathus (KOMP-sog-NAY-thus) was no larger than a chicken. Its bones were hollow and delicate like those of a bird. Such an animal, shown below in an 1896 restoration by O. C. Marsh, was likely capable of fast running, an important adaptation for a predatory lifestyle. When we consider its place in the evolutionary history of theropods, we can infer that *Compsognathus* had simple feathers on its body.

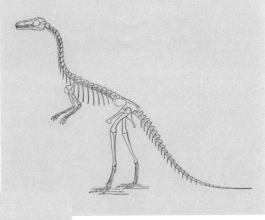

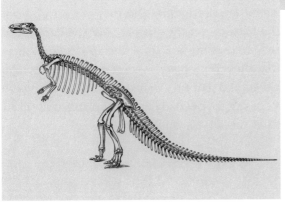

Camptosaurus (KAMP-toe-SAWR-us) was a medium-sized, bipedal herbivore and an early example of the group of ornithischians called Ornithopoda. In the mural, *Camptosaurus* is seen just beyond the tiny *Compsognathus* in the foreground. As a Jurassic ornithopod, *Camptosaurus* was an early relative of the hadrosaurids of the Cretaceous Period. Shown at left is O. C. Marsh's 1896 restoration of *Camptosaurus dispar*.

Stegosaurus (STEG-o-SAWR-us) was a herbivore that reached adult lengths of more than 20 feet (6 meters), and could have weighed as much as two elephants. Its famous "second brain" located over the hips was not a true brain, but rather a nerve bundle encased in fatty tissue. Called a **sacral ganglion**, this nerve bundle likely functioned in the management of reflexes in the tail end of the animal. All dinosaurs have a sacral ganglion, but that of *Stegosaurus* is most often discussed because the chamber that housed it was actually larger than the animal's braincase (though most of this space housed fatty tissue surrounding the spinal cord itself).

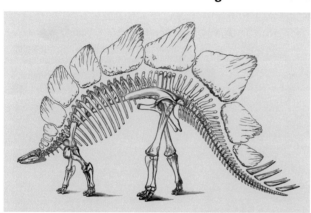

O.C. Marsh's 1896 restoration of *Stegosaurus ungulatus*.

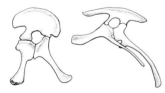

All dinosaurs belong to one of two lineages: Saurischia ("reptile hip") or Ornithischia ("bird hip"). Despite the meanings of these names, all dinosaurs are reptiles and birds are saurischians, not ornithischians. The main difference between saurischians and ornithischians is in the anatomy of the pelvis, or hip bones. In saurischian dinosaurs, the hip bones are arranged as they are in other reptiles, such as crocodiles (above, left). Ornithischian hip bones, on the other hand, resemble those of modern birds (above, right).

distinct advantage over some of their lower-to-the-ground contemporaries, like *Stegosaurus*.

Even early ornithopods like *Camptosaurus* and *Iguanodon* (not shown in the mural) showed significant adaptations for **herbivory**. Their teeth, jaws, and skull were able to sustain chewing. Reptiles today do not chew their food; instead, they gulp it down in large chunks. As evolution progressed, the ornithopod dentition became specialized into the grinding mills seen in the more derived members of the lineage, the Cretaceous "duck-billed" dinosaurs, the hadrosaurids.

Coexisting with *Camptosaurus* during the Jurassic were plated ornithischian dinosaurs of the group Stegosauria. The best-known member of this group, and the one depicted in the mural, is ***Stegosaurus***. With a blimp of a body ornamented with two rows of diamond-shaped bony plates along its back, *Stegosaurus* was one of the most unusual animals of all time. The body carried a minuscule head at the end of a short neck, and the tail sported four or more long, pointed spikes. The whole ludicrous beast walked on strangely proportioned legs, with the front legs being less than half the length of the back legs. As ridiculous as they looked, stegosaurs achieved an impressive distribution. Although only a few different types of stegosaurs are known, fossils have been discovered in North America, Europe, Asia, and Africa.

Over the years there has been much debate about the stegosaur plates. Were they paired or were they alternating? Did they project up from the back or did they lie flat over the flanks? Did they serve some biological function? Studies show that these bony plates were staggered rather than paired, and that they were upright. Given that each stegosaur species had distinctive plates, these likely had a species recognition function.

Perhaps the best known of all the creatures portrayed in *The Age of Reptiles* is **Apatosaurus**, the saurischian sauropod often incorrectly called "*Brontosaurus.*" Why did this animal's name change? Special rules govern the scientific naming of organisms. *Apatosaurus* ("deceptive lizard") was the name first applied to this animal in 1877 by O. C. Marsh, based on specimens from Morrison, Colorado. In 1879, Marsh gave the name "*Brontosaurus*" ("thunder lizard") to a similar, more nearly complete fossil specimen excavated at Como Bluff, Wyoming (this is the specimen mounted in the Peabody Museum's Great Hall). Marsh recognized that the two were related, but because *Apatosaurus* had three bones in its sacrum and "*Brontosaurus*" had five, he gave them separate names. What was not known at the time is that the number of sacral vertebrae is related to age. As the animal got older, two additional sacral vertebrae fused to the original three. It was paleontologist Elmer Riggs who, in 1903, realized that the animal called *Apatosaurus* was really a young "*Brontosaurus.*"

Once scientists showed that the two fossil specimens actually belonged to one and the same species, the first name given to the species, *Apatosaurus*, was accepted as the animal's true name; the second name, "*Brontosaurus*," became invalid. You'll notice that the name is written inside quotation marks, the proper way of indicating that it is no longer a valid scientific name.

Apatosaurus (a-PAT-o-SAWR-us) means "deceptive lizard," so named because bones from the bottom of the tail looked deceptively similar to those of mosasaurs, a group of marine reptiles. The almost complete *Apatosaurus* skeleton now in the Peabody Museum's Great Hall was excavated in 1879 at Como Bluff, Wyoming, and shipped in 25 crates to O. C. Marsh in New Haven, Connecticut.

In 1879, William Harlow Reed discovered and collected the skeleton that Marsh incorrectly described as "*Brontosaurus*" *excelsus* (the illustration below is from his 1883 description). This watercolor sketch by Arthur Lakes, a paleontologist and illustrator who accompanied the 1879 expedition, shows Reed and E. Kennedy, another of Marsh's "bone hunters," with dinosaur bones.

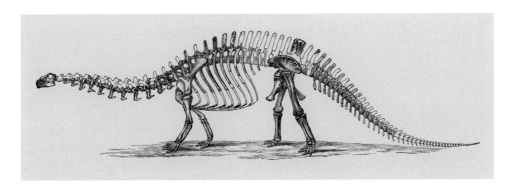

For years, scientists have named organisms using internationally accepted rules of **binomial nomenclature** in **taxonomy**. The word "binomial" refers to the two parts that make up the scientific name of a species. For many extinct dinosaurs, the first part has become the common name. For example, the common name *Apatosaurus* actually refers to three different species of dinosaur: *Apatosaurus ajax, Apatosaurus excelsus* and *Apatosaurus louisae*. The proper way to write a species name is in italics with only the first part of the name, the genus, capitalized.

Most archosaurs, a primitively carnivorous lineage that includes both crocodilians and birds, do not chew their food. Instead, they swallow stones into a muscularized foregut, the gizzard. By grinding together and reducing food material, these stones act as a substitute for chewing. Those archosaurs that ingest tough food that requires extra processing, particularly plant material, carry many stomach stones, or gastroliths, in especially large gizzards. This photograph shows a pile of gastroliths preserved in the belly of *Caudipteryx*, a small, feathered theropod from the Cretaceous of China. (Photograph courtesy of Jacques Gauthier.)

More interesting than its christening are questions about how *Apatosaurus*, at perhaps over 20 tons, was able to sustain its enormous size. Consider the fact that a four-ton African elephant eats up to 500 pounds (227 kilograms) of plant material every day and spends as much as 15 hours searching for and consuming such nourishment. Elephants also have a highly flexible food picker, the trunk, and a large mouth with massive molars for the reduction of plant matter. *Apatosaurus* had no trunk, no grinding teeth, a relatively small mouth, and weighed four or five times as much as an African elephant. Even *Apatosaurus* was small compared to the much longer *Diplodocus* and the much taller *Brachiosaurus*. This begs an interesting question: how were sauropods like *Apatosaurus* able to eat enough food?

The fossil record supports the suggestion that sauropods used **gastroliths**, grinding-mill stones in the stomach, to process large volumes of plant fiber. Gastroliths have been found in close association with sauropod skeletons. The head and long neck of a sauropod are analogous to an elephant's trunk, which only collects food that is then processed in the stomach. In addition to using gastroliths, it is possible that sauropods had metabolic rates lower than those of mammals of today and could therefore survive on much less food.

One thing is certain: sauropods almost surely did not muck around in the swamps and lakes any more than do the large terrestrial animals alive today. They were well suited to a terrestrial existence. Modern experiments have shown that the compressive strength of bone, together with the stout girth of sauropod limbs, was more than enough to provide support. Thorough studies of the animal's bone anatomy along with fossil footprint evidence have removed the last doubts that *Apatosaurus* was able to stroll about on dry land. Sauropods did not require the buoyancy of water for body support.

Taller sauropods, like *Brachiosaurus*, probably browsed high in the trees, using their long necks and tall front legs to feed on foliage well out of reach of contemporary herbivores like *Stegosaurus*

and *Camptosaurus. Apatosaurus*, however, is now thought to have been a low vegetation feeder or **grazer**. Thanks to its long neck, the animal could stand motionless and still consume huge areas of vegetation by moving its head from side to side in a sweeping arc while feeding.

Another interesting characteristic of the sauropod dinosaurs is known from evidence left behind in their fossil footprints. Footprints tell us some things about animal behavior that fossilized bones do not. Trackways discovered in Texas indicate that some sauropods traveled in herds! Because so many modern animals flock or herd, we should not be surprised to find that sauropods also assembled (perhaps for protection and safety in numbers) and moved in groups.

Pterosaurs ("winged lizards") were the first vertebrates to achieve **powered flight**. Although this surprising event in the history of life is depicted in the Jurassic section of the mural—the long-tailed ***Rhamphorhynchus*** flying just to the left of the neck of *Apatosaurus*—recently discovered fossils show that the first pterosaurs appeared late in the Triassic Period. Because they lived at the same time and in the same regions as many dinosaurs, pterosaurs are often confused with dinosaurs. Pterosaurs are not dinosaurs, but are closely related to them within the group Archosauria. They had a considerable size range; the smallest was no larger than a sparrow and the largest was the size of a small airplane. For many years, it was believed that pterosaurs were not capable of powered flight, and instead used their wings for soaring or gliding. According to this previous hypothesis, pterosaurs were presumed to be **cold-blooded** and therefore incapable of mustering the energy necessary for powered or flapping flight. Recent, careful anatomical analysis of pterosaur skeletons shows instead that the wings of all pterosaurs were well adapted for flapping flight.

 Although pterosaurs such as ***Rhamphorhynchus*** (RAM-for-INK-us) were capable of powered flight, they were only very distantly related to birds. Pterosaurs thrived for many millions of years from the Late Triassic Period until the very end of the Cretaceous Period. Most pterosaurs were probably **insectivores**, but certain peculiar forms seem to be adapted for straining seawater for fish or crustaceans. Some of the larger pterosaurs may have fed on carrion to sustain their large body mass.

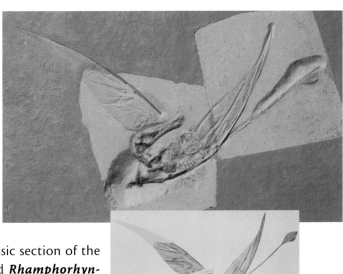

O. C. Marsh's 1882 reconstruction of *Rhamphorhynchus phyllurus* (below) was based on a truly remarkable specimen (above, YPM 1778) that Marsh purchased for the Peabody Museum's collections. Found in the same rock formation that yielded *Archaeopteryx*, this specimen preserved impressions of the animal's delicate wing membranes.

A remarkable and fortunate set of circumstances preserved the delicate, hollow bones of several **Archaeopteryx** (ark-ee-OP-ter-ix) skeletons in the fine-grained Solnhofen Limestone in what is now Bavaria, Germany. Of the few known specimens of *Archaeopteryx*, one was originally misidentified as a pterosaur and later redescribed by John Ostrom of Yale University. This painting, by Shirley P. Glaser (Hartman), is a reconstruction based on the well-known Berlin specimen of *Archaeopteryx lithographica* (at right; photograph by John Ostrom).

This brings us to a small but very important animal of the Jurassic Period, **Archaeopteryx**. There is one below the head of *Apatosaurus*, in the mural's foreground, about to perch on a cycad frond, and a second flutters across the marshy land to the right of the river. The few fossil specimens of *Archaeopteryx* show that this theropod dinosaur was covered with **flight feathers**, remarkable structures very similar to those of birds.

Archaeopteryx had well-developed teeth, a long, bony tail, and a skeleton more similar to that of *Compsognathus* than to that of a bird. Birds, or Aves, belong to a group of flying theropod dinosaurs called Avialae. When all morphological features are used to determine evolutionary relationships, *Archaeopteryx* is discovered to be a theropod dinosaur and an early member of the group Avialae. Although *Archaeopteryx* is not within the living group Aves, and therefore not a true bird, the animal has been instrumental in settling the disputes over the dinosaurian origin of birds.

Today, it is generally accepted that birds are theropod dinosaurs. This realization has incredible implications— that not all dinosaurs went extinct at the end of the Cretaceous Period. However unusual as it may sound, the earth today is inhabited by one species of human and almost 10,000 species of dinosaurs.

A TALE OF TWO HEADS

When O.C. Marsh described and named *Apatosaurus* and "*Brontosaurus*," the latter was missing its skull, so he combined features of a partial skull with a more complete "*Brontosaurus*" skull that was at the National Museum in Washington, D.C. The National Museum skull was the model for the plaster and bone sculpted skull that was mounted on "*Brontosaurus*" when it was erected in the Great Hall in 1931. It was this skull that Zallinger used for the fleshed out head of *Apatosaurus* in *The Age of Reptiles* mural.

As better and more complete skeletons of sauropods were discovered during the 20th century, paleontologists realized that Marsh's two isolated sauropod skulls really belonged to *Camarasaurus* and *Brachiosaurus*. A skull that was found in Utah in the early 1900s was finally recognized in the 1970s to be an *Apatosaurus* skull.

In a special ceremony in October 1981 honoring the 150th anniversary of O. C. Marsh's birth, the sculpted skull of the *Apatosaurus* in the Great Hall was replaced with a cast of the correct skull. Today, all of the five mounted *Apatosaurus* skeletons in the United States have casts of this skull.

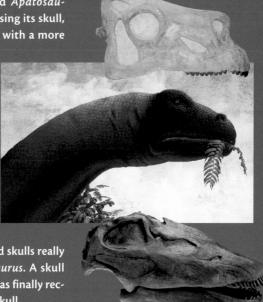

Compare the original, and incorrect, head of *Apatosaurus* (above), with the painted image in the mural (center) and the correct skull today (below).

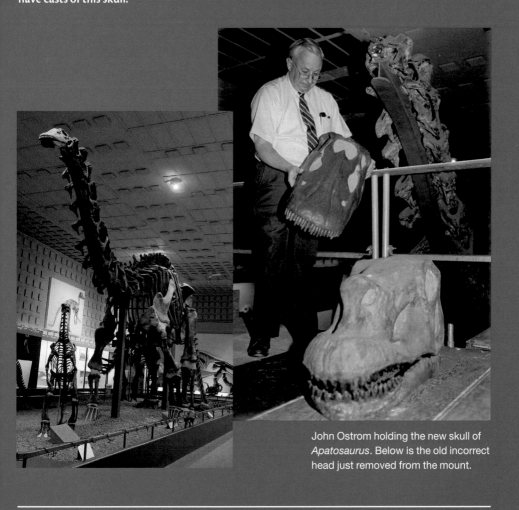

John Ostrom holding the new skull of *Apatosaurus*. Below is the old incorrect head just removed from the mount.

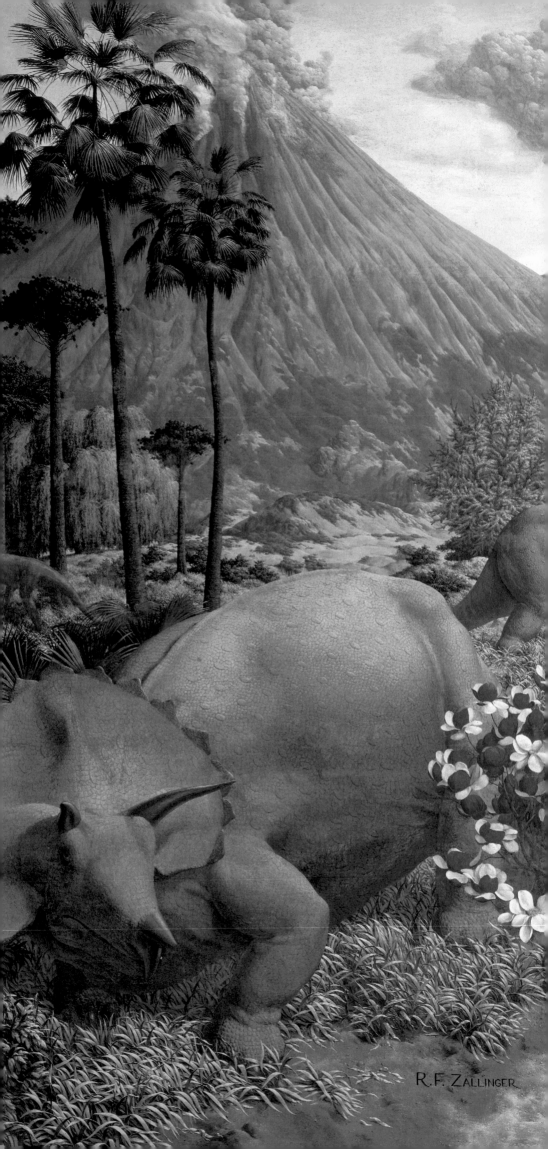
R.F. ZALLINGER

The Final Chapter: The Cretaceous Period

The last major development in the evolution of land plants to be shown in the mural was the appearance of **angiosperms**, the flowering plants, sometime around the beginning of the Cretaceous Period. During the first half of the Cretaceous, long before the asteroid impact that marks the end of the Mesozoic Era, the angiosperms rose to dominate the earth's flora and changed its ecology in fundamental ways. The extent to which angiosperms depend on insects, birds, and small mammals to carry pollen and distribute seeds has brought them into close **co-evolutionary** relationships with these animals. Many people believe that these close **symbiotic** relationships explain why flowering plant species now outnumber all other land plants by 20 or 30 to one and are overwhelmingly dominant as the source of our food energy, both directly and as food for the animals that we consume.

At the time that *The Age of Reptiles* was painted, most paleobotanists thought that Cretaceous angiosperms were very closely related to their modern descendants. So, although all the animals shown belong to extinct groups, the plants in the final, Cretaceous section of the mural are close to living species. Studies have indicated instead that many Cretaceous angiosperms, especially those from the early part of the period, were truly primitive and belonged to archaic groups only distantly related to those that make up the flora of the modern world.

Although flowering plants dominate the Cretaceous scene in the mural, we know now that other seed plants, especially the conifers, were more important and numerous then than they are today. *Ginkgo* is another example of a seed plant whose close relatives can be recognized as far back as the Jurassic Period. The last wild survivors of this once flourishing group disappeared early in historic times from their final refuge in southwestern China and were preserved only in Buddhist temple gardens. Yet an abundance of fossils convincingly shows that this plant and its extinct relatives had worldwide distribution during the Mesozoic.

Representatives of the palm family are very conspicuous in this section of the mural. One of the recognizable species is **Sabalites**, a fan palm resem-

During the Cretaceous Period, the continents continued to separate and climates were more temperate than those of the Jurassic Period. Much of North America was close to sea level or at moderate elevation. By the end of the Cretaceous, however, mountain building events once again dominated in several regions of the world. The Rocky Mountains started to develop in the Late Cretaceous, a tectonic event that Zallinger depicted in the background of the Cretaceous section of the mural. From amid this upheaval appeared a variety of new dinosaurs. (Courtesy of the U.S. Geological Survey.)

Ginkgo (JINK-go; GINK-go) and its relatives are represented in the fossil record primarily as distinctive leaf compressions, such as this specimen (YPM 30800, below) in the Peabody paleobotany collection. An abundance of Mesozoic and Tertiary fossils show convincingly the worldwide distribution of this plant and its relatives.

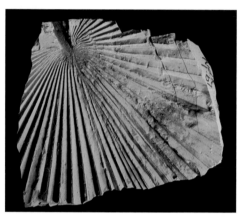

Sabalites (say-bal-EYE-tees), the fan palm, and a generalized palmetto are among the angiosperms in the mural. Below is a fossilized palm (YPM 53449) from the Late Cretaceous of Wyoming, USA.

The screw pine, **Pandanus** (pan-DAN-us), is not a palm or a pine, but rather a member of another lineage of **monocotyledonous** plants that are characteristically treelike.

Araliopsoides (a-RAL-ee-op-SOYD -dees) was a shrubby forerunner of our modern sycamore or plane tree.

The familiar dogwood, **Cornus** (kor-NUS), is not known to have existed until after the end of the Cretaceous.

The typical flowering **Magnolia** (mag-NO-lee-a) shown here actually probably evolved much later, perhaps as an adaptation to climates with distinct seasons.

bling the modern palmetto. However, no particular species has been singled out in the mural; instead, there are several palms that have this characteristic growth habit.

The screw pine, **Pandanus**, is a member of neither the pine nor the palm family, but a distant relative of the palms that grow today in moist habitats and develop a dense mass of bracing stilt-like roots between the lower trunk and the ground.

The small **Araliopsoides**, just in front of *Tyrannosaurus*, was one member of a great radiation of related plants that made up an important part of the vegetation at middle and high northern latitudes of the earth during the late Cretaceous.

The flowering shrub seen over the back of *Tyrannosaurus* looks suspiciously like a dogwood, **Cornus**, a plant that had not actually appeared by the end of the Cretaceous. So we can think of it as an extinct form that reminds us that flowers, which probably started out as small, relatively inconspicuous structures lacking showy petals, gradually became larger and more noticeable along with the evolution of their insect pollinators as the Cretaceous came to a close.

The flowering **Magnolia** partially obscuring the tail of *Tyrannosaurus* has large, showy blossoms that have opened before the leaves have appeared on the plant, a mode of growth that probably developed in the magnolias only with the advent of seasonally cold climates, well after the beginning of the Cenozoic. Cretaceous members of this ancient family grew in warm climates where there was little if any seasonal change, and would more likely have had evergreen leaves and scattered flowers that appeared over a prolonged interval, as they do in the living primitive magnolias today.

The low, densely mounded tree behind the head of the more distant of the two *Triceratops* could represent **Dryophyllum**, a probable ancestor of the modern flowering plants that include the oaks, beeches, and chestnuts, which were to appear 10 to 20 million years after the end of the Cretaceous.

The drooping shape of the tree behind the final group of palms on the left side of the mural marks it as a weeping willow, a relatively advanced member of **Salix**, a group of plants that did not appear until

after the close of the Cretaceous, so it is really out of place here. The idea that willows were contemporaries of the last dinosaurs developed from the misidentification of fossil leaves that looked superficially like those of the modern willow. We know now that these leaves actually belonged to extinct forms more closely related to the modern tea plant or the staff trees of subtropical areas.

By the end of the Cretaceous Period, archaic groups of flowering plants held sway over the earth's vegetation, at least at low latitudes and elevations, having wrested dominance from the more primitive lines of seed plants that included the conifers, the cycads, and the ginkgoes.

The animals that had characterized the Jurassic Period also gave way to a whole new assemblage in the Cretaceous Period. Armored ankylosaurs replaced their close relatives, the stegosaurs. Overhead, there flew a new cast of aerialists, including the giant fish-catching predator **Pteranodon**. Unknown at the time of the mural's painting, the Cretaceous pterosaur *Quetzalcoatlus* had an unbelievable wingspan of at least 40 feet (12 meters), a size comparable to that of a small airplane.

The ponderous, long-necked sauropods survived with several new forms appearing in the Cretaceous Period. Some of the dominant large, terrestrial herbivores were the members of a group of ornithopods called Hadrosauridae. Hadrosaurids, called "duck-billed" dinosaurs, were among the most common and diverse of the Cretaceous dinosaurs. Like *Camptosaurus* before it, **Edmontosaurus** and its relatives were able to move about either bipedally or quadrupedally. Some hadrosaurids, such as *Edmontosaurus*, had flat-top skulls. Others, such as *Parasaurolophus* (not shown in the mural), had elaborate crests on their heads that may have generated low frequency sounds used in communication, or were more likely a means of individual species recognition.

Hadrosaurids are well known for the quantity of teeth in their mouth: as many as 200! These teeth were well adapted for grinding up large batches of plant material. This is especially interesting because most reptiles today do not chew their food. That the hadrosaurids and some of their ornithopod relatives did chew suggests that these animals had

Dryophyllum (dry-o-PHILL-um) was a low, dense tree ancestral to modern oak, beech, and chestnut trees.

Out of place here in the mural, weeping willows belong to the group **Salix** (SAY-licks), which does not show up in the fossil record until at least 10 million years into the Cenozoic Era.

The giant **Pteranodon** (tair-AN-o-don), with a wingspan approaching almost 30 feet (9 meters), is shown flying beyond its terrestrial contemporary, *Tyrannosaurus*. *Pteranodon* was a great predator of Cretaceous skies. Fossilized stomach contents show that it was a fish-eater.

Edmontosaurus (ed-MONT-o-SAWR-us) is a "flat-headed" hadrosaurid. Not only were hadrosaurids abundant, but they were also diverse. Well adapted for herbivory, hadrosaurids fed on shrubs, trees, and perhaps on swamp foliage. They were browsers rather than grazers; at least one specimen has been discovered with the preserved remains of a recent meal of evergreen needles. Not illustrated in the mural are the crested hadrosaurids with their strange, hollow, bony head crests of various shapes and sizes.

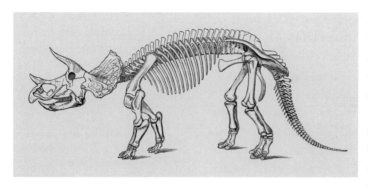

 Triceratops (tri-SAIR-a-tops), perhaps the best known of the horned, frilled ceratopsians, was first described and named by Yale's O. C. Marsh. This is Marsh's 1896 restoration of *Triceratops prorus*.

A contemporary of *Triceratops*, *Torosaurus* (not shown in the mural) had a skull more than 9 feet long (3 meters), perhaps the largest ever found for a land-living animal. The bronze sculpture in front of the Yale Peabody Museum in New Haven is a life-size reconstruction of what this animal would have looked like.

a higher metabolism than modern non-avian reptiles and could even have had a **warm-blooded** physiology. Hadrosaurids were among the last of the non-avian dinosaurs, surviving until the very end of the Cretaceous Period.

The other dominant group of terrestrial herbivores were the horned dinosaurs, the ceratopsians ("horn face"), including the well-known ***Triceratops***. There was an impressive diversity of skull horn patterns among the known ceratopsian species. These horns projected from the face and from around the edge of the frill at the back of the head. *Triceratops* had a horn at the end of its snout and one horn above each eye. There can be little doubt that these horns were for defensive or aggressive behavior, and may have been used for competition over mates. But because any horns would do for aggressive behavior, this cannot fully explain the diversity of forms. Each species had its own peculiar arrangement of horns and frills, indicating a role in species recognition.

The large ceratopsian frill, a bony expansion of the back of the skull, was once regarded as a shield for protection of the vulnerable neck region. Research shows that, just as with the *Stegosaurus* plates, the outer surface of the frill was dense with blood vessels. Along with the large surface area, this suggests that the frill could have been used to dissipate excess body heat. The frill also provided enlarged areas for the attachment of large jaw muscles and powerful neck muscles. This likely gave strong leverage for aiming and thrusting the great horns on the face. Clearly, *Triceratops* commanded respect.

The king of the Late Cretaceous Period was *Tyrannosaurus rex*. The scene here seems to show that all the late Cretaceous contemporaries except the armored *Ankylosaurus* avoided *Tyrannosaurus rex*. Nearly 18 feet (6 meters) tall and 45 feet (14 meters) in length, *Tyrannosaurus rex* probably weighed as much as six or seven tons. Although recently discovered theropods from earlier in the Mesozoic Era show that *Tyranosaurus rex* was not the largest theropod of all time, the "tyrant lizard king" will always reign in the minds of many. **Ankylosaurus**, studded with sharp spikes and sheathed in bony plates of armor, was well defended against the saber fangs and foot talons of *Tyrannosaurus rex*. In the background of the Cretaceous section of the mural is **Struthiomimus**, an ostrich-like theropod quite unlike *Tyrannosaurus*.

In one of the most electrifying paleontological discoveries of recent times, fossils unearthed in the 1990s in the Cretaceous Yixian Formation, near Sihetun, Liaoning Province, in northeastern China, have revolutionized our understanding of the origin of feathers and flight in dinosaurs. Among the Chinese fossils, exquisitely preserved skeletons of four new theropod dinosaurs—*Sinosauropteryx, Protarchaeopteryx, Caudipteryx,* and *Confuciusornis*—bear remains of feathers, although only one of them, *Confuciusornis*, could actually fly. These 120-million-year-old "feathered dinosaurs" have helped to settle the debate on the origins and early evolution of birds and feathered flight. Paleontologist John Ostrom called this discovery "the biggest event in evolutionary science since Darwin put forth his theory."

Scientists once classified birds separately from dinosaurs because birds seem so different from

No one is apt to mistake **Tyrannosaurus** (ti-RAN-o-SAWR-us), by far the most imposing of all the animals illustrated in the mural. There is much debate as to whether *Tyrannosaurus rex* was an active hunter or just a **scavenger**. The extremely small hands and arms of *Tyrannosaurus* must have made it dependent on its feet, massive skull, and great teeth to tear off large chunks of meat and bone while feeding. If this seems awkward, consider the attack of an eagle, a predator entirely without clawed hands yet efficient at tearing apart food with just its beak and foot talons. And we now have good evidence that *T. rex* had feathers!

In 2003, a tooth that had been in a drawer in the Yale Peabody Museum's Division of Vertebrate Paleontology for over 100 years was recognized as the earliest collected specimen of *Tyrannosaurus rex*. Discovered in 1874 near Denver, Colorado, by Arthur Lakes, the tooth was sent to O. C. Marsh. While Marsh must have realized that the tooth belonged to a large carnivorous dinosaur, he did not recognize it as a new type of animal. *Tyrannosaurus rex* was not described until 1905, six years after Marsh's death. Although he never knew of its existence, Marsh held in his hand the first specimen of what would arguably become one of the world's most famous dinosaurs.

At the lower right corner of the Cretaceous section of the mural is the armored dinosaur **Ankylosaurus** (AN-key-lo-SAWR-us), a cousin of the Jurassic stegosaurs.

The theropod **Struthiomimus** (STROOTH-ee-o-MIME-us) is depicted at the far left margin behind *Triceratops*. This animal, as its name suggests, looked like an ostrich. This lightly built predator could have been capable of running at high speeds, and was feathered.

This small 120- to 150-million-year-old fossil of *Sinosauropteryx* (sine-oh-sore-OP-ter-iks), or "Chinese dragon wing," was discovered in Liaoning, China, in 1996. The fossil was the first evidence of a flightless, non-avian dinosaur with protofeathers. This specimen could be a juvenile, because a similar but much larger individual was found nearby the following year. The appearance of feather precursors at such an early stage in theropod evolution shows that feathers predate flight. These structures could have earlier functioned in the retention of body heat or in the attraction of mates, or both.

forms like *Apatosaurus* or *Stegosaurus*. The Liaoning fossils have, however, erased most of the differences between birds and non-avian theropod dinosaurs. Indeed, we now know that *Struthiomimus* and *Tyrannosaurus* had feathers! These early Cretaceous fossils reveal multiple stages in the evolution of the shoulders and forelimbs of theropod dinosaurs and provide crucial evidence for how grasping arms transformed into flying wings.

In the lower left corner of the mural, nearly overlooked among the monstrous dinosaurs, lurks one small, lonely mammal, **Cimolestes**. The presence of this mammal at the end of *The Age of Reptiles* is a harbinger of things to come. Although tiny mammals and other cynodonts were contemporaries of the dinosaurs through most of the Mesozoic Era, dinosaurs filled most ecological niches. This kept mammals in check and forced them to live unassuming, nocturnal lifestyles. With the demise of non-avian dinosaurs at the end of the Cretaceous Period mammals were given an opportunity to radiate and occupy the vacated niches.

Reflecting the popular scientific opinion of the day, Zallinger's mural suggests that erupting volcanoes were responsible for the mass extinction that closed the Cretaceous Period. However, geological evidence shows that an asteroid collided with earth 65 million years ago, causing profound changes in earth's living conditions. Since the 1980s, exploration of such ideas has been one of the most active fields of inquiry in paleontology. In a geological instant, the curtain closed on the 150-million-year drama of the age of reptiles, bringing to an end the

Although it could not fly, *Caudipteryx* (Caw-DIP-ter-iks), meaning "tail feather," from the same site in China, had enlarged, more bird-like feathers on its hands and tail tip, as seen in this detail of fossil impressions of its tail feathers.

Cretaceous Period, and the Mesozoic Era. Within a geologically short period of time, the last of the non-avian dinosaurs became extinct and plants and animals began a gradual trend toward modern forms.

So it is that this vast mural captures that long-vanished, fascinating age of earth's history. Although inevitably some of the details have changed, the great milestones represented by *The Age of Reptiles* continue to resonate with a majesty that inspires us to wonder at our place in the history of life on earth.

Cimolestes (sigh-MO-les-teez) was an early shrew-like mammal. Closely related to today's carnivores, this animal is known only from tooth fossils. Zallinger did not originally include *Cimolestes* in his preliminary panel, but added the small mammal to the final mural on the day he signed *The Age of Reptiles*.

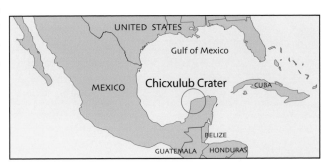

The now-buried Chicxulub Crater off the Yucatán Peninsula, Mexico, is 112 miles (180 kilometers) in diameter. Debris from the explosion that formed the crater was carried around the world through the atmosphere. The first evidence for this event was inferred from a remarkably high level of the chemical element iridium in the clay layer at the Cretaceous–Tertiary boundary that is exposed near Gubbio, Italy. High iridium concentrations have since been found in boundary material around the world. Because **meteorites** contain much more of this element than do rocks in the earth's crust, this is unambiguous confirmation of the impact of an asteroid—a giant meteorite—65 million years ago.

THE UNUSUAL THEROPOD FROM MONTANA

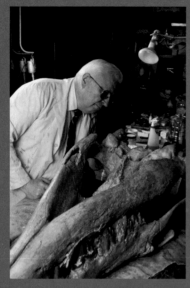

John Ostrom examining a mammal fossil in his lab in 1991.

Some discoveries in science completely change our ideas about our world. In the summer of 1964 Yale University's John Ostrom discovered in Montana a theropod dinosaur that he named *Deinonychus antirrhopus*. His scientific descriptions of this lightly built, agile predator, together with his suggestion that it could have been a gregarious pack-hunter, sparked an intense debate and heralded a revolution in the interpretation of dinosaur biology. The images of athletic, intelligent dinosaurs that we see today in movies and on television have their origins in the discovery and description of *Deinonychus*.

After working on *Deinonychus*, Ostrom intended to study the evolution of flight in pterosaurs, the flying reptiles. At a museum in the Netherlands he came across a small specimen collected from Germany over 100 years earlier that was identified as a kind of small pterosaur. Ostrom immediately recognized that this specimen was not a pterosaur at all, but rather probably a small meat-eating dinosaur similar to *Deinonychus*. Then, in tilting the fossilized bones in the light he saw the faint impressions of feathers. Knowing that this specimen was from the Solnhofen Limestone that had yielded the three then known specimens of the early flying dinosaur *Archaeopteryx*, Ostrom suspected immediately he had recognized another. It was when writing the scientific papers on his discovery of this fourth specimen of *Archaeopteryx* that Ostrom started finding many similarities between the skeletons of *Deinonychus* and *Archaeopteryx*—observations that ultimately led to one of the most influential contributions to paleontology, the maniraptoran–bird evolutionary link.

Writing in the 1970s, Ostrom clearly showed that *Deinonychus* and other closely related small, meat-eating dinosaurs with grabbing hands (now called **maniraptorans**) shared several unique bony features with *Archaeopteryx*. His work, which firmly established that it was an early maniraptoran of some kind that gave rise to birds, resurrected an earlier, previously dismissed hypothesis of a dinosaurian origin for birds. Peabody Curator of Vertebrate Paleontology Jacques Gauthier's early research on the classification of meat-eating dinosaurs verified Ostrom's hypothesis of a maniraptoran origin for birds. Gauthier's research on the bones of *Archaeopteryx* and on the com-

Deinonychus—from the Greek *deinos* meaning "terrible" and *onyx* meaning "claw" — is named for its unusual asymmetrical foot. The ungual, the most distant bone in the second toe, was covered by a sharp, sickle-shaped talon that was used to disembowel its victims. This and other features of its anatomy suggest a predator of extraordinary balance and agility.

Reconstruction of the skeleton of *Deinonychus* in a predatory, leaping pose, one of the full skeletons on display in the Peabody Museum's Great Hall. As an adult, *Deinonychus* would have reached a length of 8 to 10 feet (2.5 to 3.5 meters), stood 3 to 4 feet high (about 1 meter), and would have weighed about 130 to 165 pounds (60 to 75 kilograms).

A fossilized impression of an *Archaeopteryx* feather (photograph by John Ostrom).

parison of the hands in birds and crocodilians with the grabbing, three-fingered hand of maniraptoran dinosaurs strongly supports the idea that birds are living maniraptoran dinosaurs! Additional research also indicates that the swooping motion that maniraptoran dinosaurs like *Deinonychus* made with their arms while grabbing prey was likely the precursor to the flight stroke in birds.

The extensive paleontological collections O.C. Marsh acquired for the Yale Peabody Museum provided important supporting evidence for the 19th century's fledgling evolutionary theory, and even today the fossils he collected and described are invaluable for the study of evolutionary biology. An important contribution to the early debate on evolution was Marsh's discovery and description of the Cretaceous toothed birds *Hesperornis* (his reconstruction is shown above) and *Ichthyornis* (at left), which together with *Archaeopteryx* first linked birds and reptiles, and anticipated the work of Yale's John Ostrom in the latter half of the 20th century.

THE PEABODY'S *TOROSAURUS*

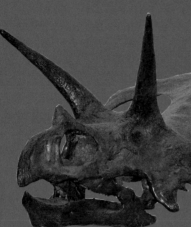

The skull of *Torosaurus latus* (YPM 1830), the type specimen, was first put on display in 1936. Note the perforations in the frill that give the *Torosaurus* its name.

The five-year project to create the 21-foot life-size bronze sculpture of *Torosaurus latus* that stands outside the Yale Peabody Museum brought together paleontologists, zoologists, and an army of artists and volunteers. Sculpted by Michael Anderson, the Museum's preparator, the making of this dinosaur required the blending of art and science.

Torosaurus latus, a horned dinosaur that lived at the end of the Cretaceous Period 66 to 65 million years ago, was chosen because of its significance in the history of the Yale Peabody Museum. It was O. C. Marsh who first described and named *Torosaurus latus* in 1891, formally establishing it as a new species. *Torosaurus* ("perforated lizard") is a member of the group of herbivorous frilled and horned dinosaurs known as ceratopsians, which also includes the more familiar *Triceratops*.

Because a complete skeleton of *Torosaurus* has never been found, Anderson used the handful of skulls that are known, along with the more widely available skeletons of the closely related *Triceratops*, for the restoration. The final sculpture is actually based on a range of species. In addition to reviewing the scientific literature to find paleontological sources on how muscles attach to bones, Anderson also spent hours researching anatomy texts of iguanas, alligators, and birds, and assisting in dissections. When possible, *Torosaurus'* closest relatives, *Triceratops* and *Chasmosaurus*, were referenced, but information from progressively more distant relatives (such as hadrosaurs, birds, alligators, lizards, turtles, and mammals) also helped answer specific questions. The process relied heavily on the Peabody's collections of fossils, cast replicas,

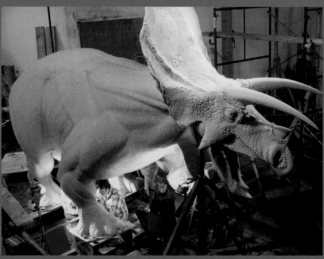

Anderson first sculpted a one-third scale model, which was then proportionally enlarged to create a life-size clay model. For the skin patterns, an educated guess of what *Torosaurus* would have looked like was based on rare fossilized sections of *Triceratops* and *Chasmosaurus* skin, along with a study of other reptilian scale patterns. About two dozen volunteers contributed 600 hours over five months to apply the scales to the full-size model.

and preserved zoological specimens. To insure accuracy, at each stage the sculpture was approved by Curator of Vertebrate Paleontology Jacques Gauthier, whose laboratory at Yale is involved in cutting-edge research on the anatomy of dinosaur musculature.

The *Torosaurus* sculpture was cast in bronze at the Polich Art Works in Newburgh, New York, from a mold of the full-scale clay sculpture. The foundry used a special casting process to prepare a series of ceramic shell molds to cast the dinosaur in pieces, which were then welded together and colored with patina. The 7,350-

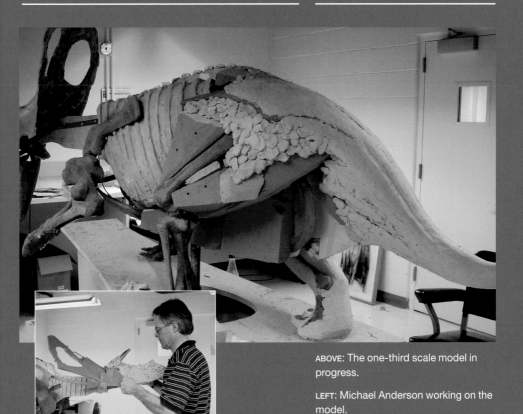

ABOVE: The one-third scale model in progress.

LEFT: Michael Anderson working on the model.

pound (3,334-kilogram) sculpture sits on a 13-foot (4 meter), 70-ton base sculpted by Darrell Petit. It is made of Stony Creek granite, the same granite used for the base of the Statue of Liberty. *Torosaurus* was dedicated at a ceremony at the Museum on October 22, 2005.

The *Torosaurus* Project was made possible through the generosity of Elizabeth R. and Stanford N. Phelps (Yale '56) and their grandchildren Max, Garrett and Ford.

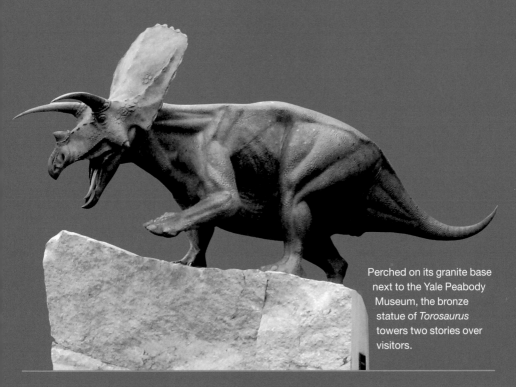

Perched on its granite base next to the Yale Peabody Museum, the bronze statue of *Torosaurus* towers two stories over visitors.

The Age of Reptiles as a Work of Art *Vincent Scully*

The dry bones in the Great Hall of the Peabody Museum of Natural History are brought to life by a magnificent fresco of enormous size which, despite its majestic rhythms and titanic theme, is as colorful and decorative as a fine cyclorama of the early 19th century or, though its scale is much grander, as one of the best of the scenic wallpapers of that period. The scene is awesome but not violent. The great beasts wander through a luminous landscape and display themselves to us, ruminant and bemused. Only *Allosaurus*, near the center, is tearing at something on the ground, and that a substance ill-defined. There are no horrors here. It is pastoral painting, idyllic and as full of peace, of nostalgia even, as the ideal landscapes of Claude.

But Rudolph Zallinger's fresco is based on artistic traditions much older than those of the 17th century. It owes its technical structure—really its fundamental conceptual stance—to a treatise on the art of painting written about A.D. 1400 by an Italian painter named Cennino Cennini. By the 1930s, in a development hard to credit, Cennini's *Libro dell'Arte* had become the bible of the Yale School of the Fine Arts, where Zallinger was trained.

It is fair to suppose that Cennino d'Andrea Cennini of Colle di Val d'Elsa would have been surprised at the uses to which Zallinger put the techniques of painting he so lovingly described. Not Adam and Eve but *Eryops* and *Diplovertebron* occupy the Carboniferous Garden in Zallinger's mural, and long before the pharaoh, *Tyrannosaurus* is king. But the essence of Zallinger's work derives in the end from Cennini; the mural could not have been what it is without him.

It is not too much to say that Cennini and his immediate forebears themselves set in motion the whole series of human thoughts and actions that resulted not only in the discovery of the dinosaurs but in Zallinger's painting of them as well. Cennini's method was, from his point of view, a rigorously scientific one. He was the pupil of Agnolo Gaddi, who had, in turn, been the pupil of his father, Taddeo Gaddi, who had been the disciple of Giotto, who began it all so far as painting is concerned. Giotto wanted to see reality as it was and to find means to create the illusion of it in the two dimensions of painting. He wanted, most of all, to endow the human presence with palpable weight and dignity

In the beginning, when almighty God created heaven and earth, above all animals and foods he created men and women in his own image... .

Cennino Cennini,
Il Libro dell'Arte, c. A.D. 1400

Daniel Varney Thompson's 1933 translation of Cennini's *Il Libro dell'Arte*. (Courtesy of Yale University Press.)

Vincent Scully is Sterling Professor Emeritus of the History of Art, Yale University. He has taught hundreds of students in packed lecture halls at Yale and several of his students have gone on to become important American architects. He has published many articles and more than a dozen books which span a wide spectrum of subject matter, and is one of the University's most recognized scholars. Among Scully's most well known works are: *The Shingle Style: Architectural Theory and Design from Richardson to the Origins of Wright*; *Frank Lloyd Wright*; *The Earth, the Temple, and the Gods: Greek Sacred Architecture*; *Louis I. Kahn*; *Pueblo: Mountain, Village, Dance*; *The Villas of Palladio*; and *Architecture: The Natural and the Manmade*.

Detail of *Lamentation over Christ* by Giotto di Bondone (1266–1336). Fresco, Scrovegni Chapel, Padua, Italy. (Cameraphoto/Art Resource, NY.)

and to set it in the center of the world stage. So his human figures are solid, three-dimensional masses standing in spatial environments that are just big enough to contain them and allow them to move and relate to each other like actors on a stage. It was the scientific instinct translated into artifice in order to make human action seem significant and wholly real.

Hence science, as theory, comes first for Cennini. He tells us that Adam, driven from Paradise, turned to labor, and that "Man thereafter pursued many useful occupations, differing from each other; and some were, and are, more theoretical than others; they could not all be alike, since theory is the most worthy." But painting comes close, since in it theory is "coupled with skill of hand...and calls for imagination...in order to discover things not seen, hiding themselves under the shadow of natural objects, and to fix them with the hand, presenting to plain sight what does not actually exist."

Out of this program Giotto's saints and Zallinger's dinosaurs alike take form. The link between them is a profoundly technical one. Cennini describes in considerable detail how to model shapes in order to make them look three-dimensional. When painting on wooden panel, he prefers colors tempered with egg yolk, which binds the pigment and makes it hard. Oil painting, which encourages a much looser brush stroke and transparent glazes, had not yet been invented, but tempera exactly served Giotto's and Cennini's intentions, which were to render their shapes sculpturally distinct, with clear linear edges and smooth surface planes. For painting on walls, Cennini prefers *buon fresco*, where the colors, tempered in this case by casein glue, were painted onto, literally into, wet plaster, so bonding the whole surface integrally into the wall. If this method proved impractical—perhaps, as Zallinger once wrote, because of a desire for "intricacies of detail not possible" in it—*fresco secco* could be employed, wherein the pigments are applied to plaster already dry, so giving the painter more time to elaborate and to make up his

mind. Still, in this technique as in tempera, the resultant forms can well be hard and linear, with distinctly articulated parts. They are also durable; their surfaces are closed, impermeable. They deal, of course, with illusion, but the deep mythic conviction that has driven those painters who have been dominated by tempera and its derivatives over the ages is that the forms they shape are most of all exact—real in some ancient, magical, objective sense, not merely illusions. Again, it is an art that wants to hold close to theory, to be scientifically correct. As such, the theory and practice of painting in tempera and fresco dominated the curriculum of the Yale School of the Fine Arts during the years 1937–1950, when Lewis Edwin York was chairman of painting there. Cennini's treatise was the center of it all. York himself was a convinced disciple of Daniel Varney Thompson, from whose so far definitive translation of Cennini's *Libro* our quotations have been drawn.[1]

Lewis Edwin York in January 1939 with students in a tempera class. (Manuscripts and Archives, Yale University Library.)

Thompson should probably be seen as a late flowering of that English, 19th-century, medievalizing impulse which had equated art with truth and craftsmanship with moral good. It is precisely in this that Thompson believed, but he was not like the French Gothic theorists of the 14th century, who thundered at the Milanese, "*Ars sine scientia nihil est,*" so canonically elevating theory above practice. Instead, Thompson was visual, and he quotes the great Henri Focillon—who was himself a visiting professor at Yale during the late 1930s and early 1940s—to the effect that "style and technique are inseparable."

Accepting that proposition as true enough, it is still a matter of some wonder that an American art school could have given itself over so wholeheartedly and so rigorously to such a restrictive, late-medieval form of theory and practice. The explanation, if any, has to be complex. To be late-medieval was no problem in itself; it could seem reasonable enough in the Gothic Yale of the 1930s. Nor was Cennini considered restrictive; he was simply expounding the scientific, chemical truth, and he seemed to offer a respectable way out of the

Josef Albers with his collection of pre-Columbian miniatures, 1970s. (Photograph by Henri Cartier-Bresson. Courtesy of the Josef and Anni Albers Foundation.)

uncertainties and ambiguities of modernism into a more stable world of permanent, if circumscribed, reality. Craftsmanship was the key. Who could gainsay it? And it was after all just as "modern" to believe in that kind of materialism as in the "functionalism" that advanced architectural theorists were espousing at the time. Clearly it was in the end an obsession, not entirely amenable to rational argument. But art is always so in one way or another, and perhaps especially the teaching of art, a process that, if not rooted in some kind of mad assurance, is always endlessly frustrated and problematic.

When, for example, York resigned as chairman in 1950 and was succeeded by Josef Albers, the quality of hermetic obsession was by no means lessened in the school; it was, in fact, powerfully increased in some ways. Albers, an inspired teacher, was a product of Bauhaus ideology, and he despised not only York's methods and the paintings that derived from them but also the oceanic contemporary work of American abstract expressionism, which he called *Schmierkunst*. He himself soon came to paint only abstract squares, as technically precise in pigment as anything prescribed by Cennini, and so "scientific" in method that the precise illusionary effects of their colors upon each other were exactly calculated and the recipe for them written on the back of the canvas. Under him, of course, greater lip service was paid to originality and individual invention in the modern manner; but, in fact, the whole tone of the school was dominated by the restrictive aesthetic assumptions of the Bauhaus, no less irrational and obsessive than those in force before.[2] In consequence, Zallinger left the school, and the whole way of painting his own work embodied fell into total disfavor—from which, I think it is fair to say, it has not yet recovered as it deserves to have done. Despite its enormous popular and scientific success (Zallinger received a Pulitzer award for *The Age of Reptiles* in 1949), the great fresco itself has not been valued as it ought to be by modern critics or accorded the distinguished position among contemporary mural paintings to which, though extremely difficult to place, it is abundantly entitled. This has in part been the case not only because it has been regarded as "mere illustration," but also because it has seemed the relic of a lost cause, of a curious day gone by.

Yet it is fair to say that only a painter trained as Zallinger was could have accomplished the wonder that he brought about in the Great Hall. It is highly unlikely that a student trained by Albers could have mastered either the purely chemical problems involved in fresco or the more complicated conceptual and technical difficulties inherent in the necessity for scientifically accurate representation of the plants and animals themselves. Daniel Thompson said that Zallinger's wall was "the most important one since the 15th century." It was surely his own dream come true: pure late-medieval fresco brought to life again at monumental scale.

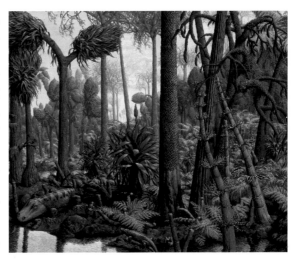

Detail from the Carboniferous Period section of *The Age of Reptiles*.

But the relationship of *The Age of Reptiles* with the Middle Ages is much more than skin deep and goes far beyond technical considerations. Like Giotto and the others, for example, Zallinger was responsible to external authority for the correctness of his forms, he to the scientists of the Peabody as Giotto to his clergy. A saint has certain attributes; the facts of the gospels are dogmatic. So are bones, at least as interpreted by scientific authority. It is obvious that Zallinger had even less leeway to embroider and reinterpret than Giotto had. Certainly his position was exactly the opposite of that of the canonical "modern" artist: the inventor, the creator of new worlds. Zallinger was essentially not allowed to "invent" at all. But he had to find cunning ways "to discover things not seen" and to present "to plain sight what does not actually exist." In this case these were most of all the eyes and the movements, the skin and the muscles with which the fossil bones might be presumed to have been clad. Here, too, Zallinger had expert direction, but Cennini's technique was his perfect tool and his guide. It is all Cennini: the study model painted in tempera on wood panel, then the drawing on the wall, the painstaking undermodeling of the bodies in monochrome, their working up with highlights, and finally the exact application of clearly differentiated colors, smoothly tempered and firm, in the realization of the forms.

Zallinger's landscape, too, recalls Giotto and

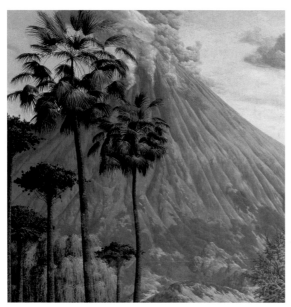

Detail from the Cretaceous Period section of *The Age of Reptiles*.

Cennini, especially in the naked mountains of the background and, most strikingly, in the hot and glowing Permian buttes, studied as if from single rocks, as Cennini had advised. Curiously, too, the wonderfully realized archaic vegetation, especially that of the earlier periods, resembles Giotto's primitive, archetypal trees. In *The Age of Reptiles*, though, the grand and somehow deeply tragic progression from the dominance of the landscape on the right toward the dominance of the animal forms on the left is all Zallinger's. In that powerful movement Zallinger brings off the extraordinary optical feat of making us read the whole long sequence easily from right to left rather than in the opposite direction, to which we are accustomed. Below the fresco the great bones of *Triceratops*, *Edmontosaurus* (also known as "Anatosaurus"), and *Tyrannosaurus* are all displayed at the left, the north side of the Great Hall, and the sequence of time in the mural was adjusted to bring the Cretaceous Period, during which these animals lived, to the wall directly above them. That ingenious merger of dramatic unity with chronological development also belongs to Zallinger and was a major conceptual and technical feat of his own.

So the mural starts on the right, all swamp and few animals, and then lunges into the deep space defined by the Permian cliffs, all of it glowing with hot pink heat and then turning sandy and greener and coming symphonically forward in the teeming and already colossal life of the Triassic Period to climax, dark and grand, with the gray lords of creation and the lush green foliage and flowering shrubs of the Cretaceous, where slate blue volcanoes smoke far off at the last. Back there, too, a *"Brontosaurus"* (*Apatosaurus*) plods, shaking the earth from afar.

Everywhere the space is deep, punctuated with figures in echelon and diminishing to little treed mesas far away. That deeply receding space is very important to the fresco. It suggests an earth young and uncrowded, open to many wonders. In contrast, Zallinger's much smaller *The Age of Mammals*

of 1961–1967, also in the Peabody, is choked with greenery and, with the exception of the trumpeting mammoth who concludes it, the animal forms are much less isolated and arresting than those in *The Age of Reptiles*, where, dominating the whole scene, a mighty *"Brontosaurus"* stands. He is mountainous himself, balancing the older cliffs, his head standing out against the open sky, and he is thrust forward by the

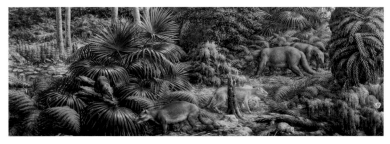

Detail from *The Age of Mammals*. (© 1966, 1975, 1989, 1991, 2000, Peabody Museum of Natural History, Yale University.)

river in which he wades almost into the space of the Great Hall below. Down there, of course, his great skeleton, an eminently incredible structure, looms, filling the vast space. Indeed, the mural as a whole is best seen looking up through it, all the fleshed bodies deploying behind the armature of bone. Curiously, in all that painted life, only two eyes seem to engage our own. They are both glowing yellow: that of *Eryops* out of the swamp, who seems to look at us; that of *Tyrannosaurus*, who emphatically does not.

In the end all the deep movements of the mural are slow and solemn. Those qualities are in accord with the view of dinosaurs that was held at the time it was painted. They were above all believed to have been ponderous and slow. The same qualities are inherent in the techniques of tempera and *fresco secco*, if even more markedly in the former than in the latter; and it should be remembered that Zallinger painted the model for his mural in tempera first. It is therefore not surprising that even the pigment of the forms on the wall itself has some of the smooth, matte, thick-bodied look of tempera. The fresco is by no means a mechanical copy of the tempera painting but, since Zallinger has always equated the two techniques very closely, they share the same technical family. The static solemnity of the forms, then, measured and majestic as they are, exactly embodies the meaning of the subject as it was expounded to Zallinger and as his technique uniquely fitted him to paint it.

A contrast between Zallinger's lumbering predators and Charles Knight's fighting group of *Dryptosauri* of 1897 is instructive in this regard.[3] Knight's

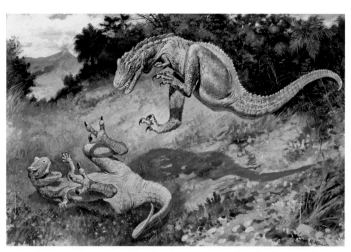

A painting by Charles R. Knight of a pair of carnivorous dinosaurs of the genus *Dryptosaurus*, based on descriptions given by paleontologist Edwin Drinker Cope. (© American Museum of Natural History. Image no. 1775.)

dinosaurs, shimmering in gouache, are as active as cats. It is difficult to imagine Zallinger's solid, rather torpid creatures moving like that. In fact, by his time nobody seemed to think that dinosaurs had ever done so. Now the research of scholars like Robert Bakker, illustrated by his lively line drawings, heralds what he calls "The Return of the Dancing Dinosaurs,"[4] standing on their hind legs and running like Olympic sprinters, their great hip joints working away. (Bakker himself was introduced to the painting of dinosaurs and drawn to paleontology by Zallinger's mural.) There are other paintings in oil on canvas that bring dinosaurs to mammal-like life—one by Bakker's student Gregory Paul, entitled "*Monoclonius apertus* Herd Crossing a Stream." Here these creatures seem much like a herd of buffalo.[5] It is hard to think of them as reptiles or as cold-blooded. The same is true of Paul's "*Chasmosaurus sternbergii* Herd in Dry Cypress Swamp,"[6] where, their front legs no longer abjectly bowed like those of Zallinger's *Triceratops*, the animals thrash about in anger and toss their armored heads like disturbed elephants or giant rhinos.

Down below the mural, too, John Ostrom's *Deinonychus*, unknown in Zallinger's time, now leaps screaming through the air like some extra-terrible primate, all teeth and claws and absolute monkey-like, bird-like agility. Clearly, a new life has come to the dinosaurs in recent years, one that is in some deep way much closer to our own. They inhabit a new kind of environment as well. Like Mark Hallett's gigantic herbivores in "Crossing the Flats," they can now move in changing weather, through the vapors of atmosphere and moisture-charged light.[7] Still, it may be that none of those settings is quite so telling as the world of meticulously rendered ancient flora, changing from age to age, through which Zallinger's dinosaurs roam.

Zallinger's forms are, like those of Giotto, preatmospheric. They are what the great art-historical polarizer Heinrich Wölfflin called linear and planar

rather than paint-
erly, their forms
closed rather than
open, revealed as by
internal modeling
rather than emerg-
ing from the vaga-
ries of external light.
They—plants and
animals alike—are
sculptural, time-
less. They are also,
on their own terms,
incomparable, as

Zallinger's signature on *The Age of Reptiles*.

is Zallinger's majestic mural as a whole, born as it
was out of that special, rather miraculous, but truly
momentary union between a painting school's ob-
session and a particular scientific point of view.

But *The Age of Reptiles* is a work of art, by its
own nature inevitably transcending science or sub-
verting it and bringing to it its own special glow.
Should we not then be able to compare it with
other works of art of its own period in time? Has it
no family other than that to which it is related only
by the painting of dinosaurs? In fact, it is difficult to
compare it with anything else. The great frescoes
executed in Mexico during the 1920s and 1930s by
painters such as Orozco and Rivera do indeed come
to mind, but the passion those works embody is so
directly cultural and tragic, their level of emotional
violence so high, that they move out into thunder-
ous realms of imagination and feeling far beyond
Zallinger's range, or at least wholly foreign to it.
The extensive collection of murals painted in the
United States during the 1930s under the Works
Progress Administration seems on the whole even
farther away from Zallinger's work. Almost none
of them are in fresco, for one thing, and, with the
exception of Grant Wood's works, most of them
embody the quick, nervous glance of the illustrator
rather than the fresco painter's magisterial, archi-
tectural eye. Benton especially is powerful carica-
ture, all red-necked honky-tonks and hardscrabble
farms. Grant Wood is a little closer to Zallinger; his
painting, too, shows the influence of Giotto. But his
human figures, sculpturally solid and standing clear
in their stages of space, much more obviously re-
call Giotto than Zallinger's bestiary in its landscape

1 Daniel V. Thompson Jr., trans. 1933. Cennino Cennini, *Il Libro dell'Arte: The Craftsman's Handbook*. New Haven: Yale University Press. In a memoir now in Manuscripts and Archives, Yale University Library, Deane Keller, who studied and taught at the school for more than 40 years, writes, "In 1927 Daniel V. Thompson came to Yale and brought tempera and fresco painting techniques to the school," and he calls Zallinger's mural "the most remarkable achievement" of this era at Yale. Yale Miscellaneous Manuscripts Collection Vol. 2, 1258 n. 32.

2 In his heartbroken memoir, Keller notes that under Albers he—a distinguished portraitist who had been teaching for a generation—was "not allowed to teach any classes to professional students."

3 In Sylvia J. Czerkas and Everett C. Olson, eds. 1987. Vol. 1, *Dinosaurs Past and Present: An Exhibition and Symposium Organized by the Natural History Museum of Los Angeles County, 1986*. Seattle and London: University of Washington Press; pp. 30–31.

4 Czerkas and Olson, vol. 1, pp. 40–41.

5 In Sylvia J. Czerkas and Everett C. Olson, eds. 1987. Vol. 2, *Dinosaurs Past and Present: An Exhibition and Symposium Organized by the Natural History Museum of Los Angeles County, 1986*. Seattle and London: University of Washington Press; p. 109.

6 Czerkas and Olson, vol. 1, pp. 22–23.

7 Czerkas and Olson, vol. 2, pp. 100–101.

can do. Curiously, Ben Shahn may be the closest, perhaps in part because his men have an animal remoteness about them, perhaps also because, as in the Public School and Community Center, Roosevelt, New Jersey, he can paint in fresco too. But Shahn blows his wall apart in marvelous ways, while Zallinger, despite his deep spatial rhythms, fundamentally respects its plane. But in the end, above all, it is human culture Shahn deals with, observed with the irony that almost all the other painters of the American scene have employed.

Not *The Age of Reptiles*. It is utterly devoid of irony and, in fact, contains no reference to human culture of any kind. Appropriate that it was begun in 1942, just as World War II got well under way for America. The American Scene in art surely died in part from that event. And here is something else—without homeland, invoking science, and asking us to believe in a world we have never seen. Abstract expressionism was to come next, where the leap of belief was into the ocean of time.

Cennini writes in the end that, beyond all theory, "the painter is given freedom to compose a figure, standing, seated, half-man, half-horse, as he pleases...." "Half-man, half-horse"—if he had only known. Neither centaurs nor saints, not American farmers or Mexican revolutionaries, inform this wall; it is the habitat of more than mythical creatures, who dominated the earth much longer than humankind now seems likely to do, and humanity's feverish mythologies and little styles tend to fade away before them. But we seem to recognize some ancient truth in them which the more recent paintings of dinosaurs may not touch upon so closely; perhaps we remember something basic to our nature, hear once again the old authentic tread of the divine. In them the animals are the gods once more, and far more dread than we painted them on the walls of caves just yesterday.

Glossary

actinopterygian a bony, ray-finned fish

adaptation a feature of an organism that results from evolutionary processes and has the effect of improving the organism's reproductive success

adaptive radiation rapid speciation made possible by the introduction of unoccupied ecological niches

alga (*pl.* algae) an organism (ranging in size from single cells to giant kelp) that lives in water, uses photosynthesis, and lacks the roots, stems, leaves, and specialized reproduction of plants

amniote a member of the Amniota, a group of **vertebrates** whose embryos develop internally

angiosperm a flowering plant

apex (*pl.* apices) the tip of a plant stem where growth occurs

archosaur a member of the Archosauria, a group of reptiles today represented by birds and crocodiles

asthenosphere the fluid mantle layer below the earth's crust

axis (*pl.* axes) the main areas of growth on a plant

basal located at the base; in **cladistics**, describes the earliest diverging group in a **lineage** of organisms

binomial nomenclature the system in which two parts make up the scientific name of a species

bipedalism the ability to stand and move on two legs

browser a plant-eating animal that specializes in the retrieval and consumption of shrubs and leafy plants

bryophyte a plant of the Bryophyta, organisms that use photosynthesis but lack a **vascular system**, such as mosses and liverworts

cladistics a method of modeling the evolutionary history of organisms

cladogram in **cladistics**, a diagram that shows the relationships among the major groups of organisms

co-evolution genetic change across the generations of two different species resulting from selective pressures that each species applies to the other

cold-blooded refers to animals who use external, environmental means to control body temperature

cuticle a waxy, water-repellent coating that helps to maintain a plant's internal moisture

cynodont an extinct mammal-like reptile

derived in evolutionary biology, a more advanced characteristic of an organism

dinosaur an organism descended from the **most recent common ancestor** of the Saurischia and Ornithischia **lineages**

embolomere a member of a group of early marine **piscivore** amphibians with long bodies

eupelycosaur a member of a group of early terrestrial mammal-like reptiles

evolution genetic changes to a population between generations

flight feather a large, vaned structure on the wing or tail of an organism necessary for sustained aerial locomotion

gametophyte in plants, the multicellular structure required for sexual reproduction

gastroliths stones that are swallowed and carried in the gizzard to help reduce plant matter; most often used by plant-eating animals that do not have grinding teeth

genus (*pl.* genera) in **taxonomy**, the first word that forms the name of a species; can be used alone to designate a biological classification of related organisms

geologic time the expanse of time that stretches back to the formation of the earth

glaciation	the process by which the earth is covered by ice sheets that spread outward from the poles	**neural spine**	a bony structure that projects from a vertebra of the spine
grazer	a plant-eating animal that specializes in the retrieval and consumption of grasses	**niche**	the particular role and relationship of a population or species within an ecosystem
gymnosperm	a nonflowering seed plant	**obligatory bipedalism**	two-legged locomotion made necessary by skeletal features that makes four-legged motion inefficient or impossible
herbaceous	having the characteristics of a nonwoody plant		
herbivory	the consumption of plant material		
heritable	capable of being passed from one generation to the next through the genes	**orogeny**	a mountain-building event
		ornithopod	a member of the Ornithischia, a group of bipedal dinosaurs
insectivore	an organism that specializes in the consumption of insects	**paleobotanist**	a scientist who specializes in the study of ancient plant life
lithosphere	the earth's rigid outer crust	**paleontology**	the study of ancient life
lineage	organisms connected by a continuous line of descent from parent to offspring	**petrifaction**	the process by which organic material is replaced by minerals over time
maniraptoran	in **phylogeny**, describes a group of organisms that includes birds and closely related dinosaurs that share common traits such as feathers and long arms and hands	**photosynthesis**	the process by which certain organisms change light energy into chemical energy
		phylogeny	the history of similarities and differences among **lineages** of organisms as they change through time
metabolism	biochemical processes by which organic matter is produced, maintained, and destroyed and by which energy is made available to continue these processes	**piscivore**	an organism that specializes in the consumption of fish
		pollination	in flowering plants, the transfer of pollen to a flower for fertilization and reproduction
meteorite	any stone or metallic object of extraterrestrial origin that strikes the earth, moon, or other planetary body	**powered flight**	sustained air locomotion through the flapping of wings
monocotyledonous	pertaining to monocots, a class of **herbaceous** seed plants whose embryos have one cotyledon (initial leaf)	**predation**	obtaining food by killing and consuming animals
		protofeather	a simple, thread-like structure in early **theropods** that represents an early stage in the evolution of feathers
most recent common ancestor	in **cladistics**, the latest individual from which specified groups are descended		
		quadrupedalism	the ability to stand and move on four legs
natural selection	the process of evolutionary change wherein advantageous, **heritable** traits become more prevalent in a population due to the increased likelihood that the organisms that have them will survive and reproduce	**respiration**	the process in which an organism takes in oxygen and gives out carbon dioxide

sacral ganglion a bundle of nerves near the pelvis; incorrectly believed to be a dinosaur's second brain, it is not under conscious control

sarcopterygian a member of the lobe-finned **lineage** of **vertebrates**

scavenger an organism that specializes in the consumption of already dead organic matter

seed the protected embryo of a plant

species a biological unit of related organisms with common features; recognizable in the fossil record through similarity in form and structure

spore a one-celled reproductive structure that develops into a new organism through asexual reproduction

stomate (*pl.* stomata) a small pore that controls the exchange of gases in a plant

symbiosis the relationship between two different organisms that depend on each other

taxon (*pl.* taxa) a grouping of organisms

taxonomy the science of classifying and naming organisms

teleost a member of a group of ray-finned fish that is the dominant group of modern aquatic **vertebrates**

temnospondyl a member of an extinct diverse group of early aquatic **tetrapods** that evolved an amphibious lifestyle

tetrapod a **vertebrate** with two pairs of limbs

tetrapodomorph a member of the group Tetrapodomorpha, a **lineage** of limbed vertebrates that led to the modern group Tetrapoda

therapsid a member of a major group of reptiles, the Therapsida

theropod a member of the Theropoda, a group of carnivorous bipedal saurischian dinosaurs

vascular system in plants, a system of channels to transport fluids, similar to the circulatory system in animals

vertebrate an animal with a spinal column

warm-blooded refers to animals with internal, physiological control of body temperature

Resources for Further Study

This guide is appropriate for National Science Education Standards Grades 9–12 Content Standards A, C, D, and G, and the Unifying Concepts and Processes.

National Education Science Standards. National Research Council. National Academic Press, 1996.

BOOKS

General

The Guild Handbook of Scientific Illustration, 2nd ed. Edited by Elaine R. S. Hodges. John Wiley & Sons, Inc., 2003.

The Work of Nature: How the Diversity of Life Sustains Us. Yvonne Baskin. Island Press, 1997.

Animals

The Dinosauria, 2nd ed. Edited by David B. Weishampel, Peter Dodson, and Halszka Osmolska. University of California Press, 2004.

Fossils of the Burgess Shale. Derek E. G. Briggs, Donald H. Erwin, and Frederick J. Collier. Smithsonian Institution Press, 1994.

Living Fossil: The Story of the Coelacanth. Keith Stewart Thomson. W. W. Norton, 1991.

Marsh's Dinosaurs: The Collections from Como Bluff, 2nd ed. John H. Ostrom and John S. McIntosh. Yale University Press, 2000.

Trilobites, 2nd ed. R. Levi-Setti. Chicago University Press, 1993.

Trilobite! Eyewitness to Evolution. R. A. Fortey. Knopf, 2000.

Wonderful Life: The Burgess Shale and the Nature of History. Stephen J. Gould. W. W. Norton, 1989.

Plants

Amber: Window to the Past. David A. Grimaldi. Henry N. Abrams, Inc., 1996.

Araucaria. Walter Jung, Alfred Selmeier, and Ulrich Dernbach. D'oro-Verlag, 1992.

Common Fossil Plants of Western North America, 2nd ed. William D. Tidwell. Smithsonian Institution Press, 1998.

The Forest Primeval: The Geologic History of Wood and Petrified Forests. Leo J. Hickey. Yale Peabody Museum, 2003.

The Fossils of Florissant. Herbert W. Meyer. Smithsonian Books, 2003.

Paleobotany and the Evolution of Plants, 2nd ed. W. N. Stewart and G. W. Rothwell. Cambridge University Press, 1993.

INTERNET RESOURCES

The Complete Works of Charles Darwin Online
http://darwin-online.org.uk/

Geological Society of America
http://www.geosociety.org/

International Commission on Stratigraphy
http://www.stratigraphy.org/

Metasequoia Research
http://www.skidmore.edu/gis/research/metasequoia/

The Paleontology Portal
http://www.paleoportal.org/

The Tree of Life Web Project
http://tolweb.org/tree/

Understanding Evolution
University of California Museum of Paleontology
http://evolution.berkeley.edu/

U. S. Geological Survey
http://www.usgs.gov/